99 Solarized Images

Joe Constantino

authorHOUSE®

AuthorHouse™ LLC
1663 Liberty Drive
Bloomington, IN 47403
www.authorhouse.com
Phone: 1-800-839-8640

© 2014 Joe Constantino. All rights reserved.

*No part of this book may be reproduced, stored in a retrieval system, or transmitted
by any means without the written permission of the author.*

Published by AuthorHouse 08/07/2014

ISBN: 978-1-4969-2845-0 (sc)
ISBN: 978-1-4969-2844-3 (e)

Library of Congress Control Number: 2014913183

*Any people depicted in stock imagery provided by Thinkstock are models,
and such images are being used for illustrative purposes only.
Certain stock imagery © Thinkstock.*

This book is printed on acid-free paper.

*Because of the dynamic nature of the Internet, any web addresses or links contained in this book may have changed
since publication and may no longer be valid. The views expressed in this work are solely those of the author and do
not necessarily reflect the views of the publisher, and the publisher hereby disclaims any responsibility for them.*

PREFACE

In 1929 Lee Miller, Man Ray's assistant, accidentally turned on the light during the development of an image and solarization occurred. It was obvious that Man Ray liked what he saw because he further developed the process and was known as the photographer who perfected the solarization process. This was further developed by Wynn Bullock whose solarization images are exhibited in museums throughout the world.

The solarization process has been practiced since the advent of photography. Simply stated solarization is the partial or wholly reversal of tones of an image. This results in an abstract image. Abstract is a departure from reality which means that a monochrome image is technically an abstraction because we see things in color and not black and white. In the conventional darkroom solarization occurred when a light was turned on during development. Results were somewhat inconsistent due to the many variables, the wattage of the bulb, how long the light was on, at what point was the light turned on while the image was being developed.

There is no standard for art appreciation. Each individual must determine his or her preferences, why does one like or dislike the image of what they are viewing. The first question that needs to be answered is why does one like or dislike the image. This is usually determined by the individual's background, environment, and experience. A quick glance is often the way the image is viewed. However, a solarized image requires more than a glance. It is more involved and because of the tone reversal more time is needed to establish the acceptance or denial of the image.

The photos that follow are divided into four sections: New York City, Interesting and Historical Sites, Graphics, and Street Photography. Some of the pictures will be familiar to the viewer but they are presented in a different and unique way. That will make the viewing somewhat more interesting and perhaps more challenging. Each section has a short introduction to make the viewing a pleasant and enjoyable experience.

PART 1

NEW YORK CITY

The many cultures, nationalities, and ethnic groups all come together to form one of the greatest cities in the world. This cosmos of international traffic is further enhanced by the many suburbs whose workers travel to New York City on a daily basis. Three hundred thousand people are transported daily by the Long Island Railroad alone. It is no wonder that so many historic and contemporary buildings and sites are present to form a legacy that will continue for many millenniums.

Presented in part 1 are some of these buildings and structures that are traditionally part of New York and they are presented in a different view so the viewer may be able to approach the city from another vantage point. However, from the old to the new they still represent and are part of the golden age that is New York.

Brooklyn Bridge and Hot Dog Stand

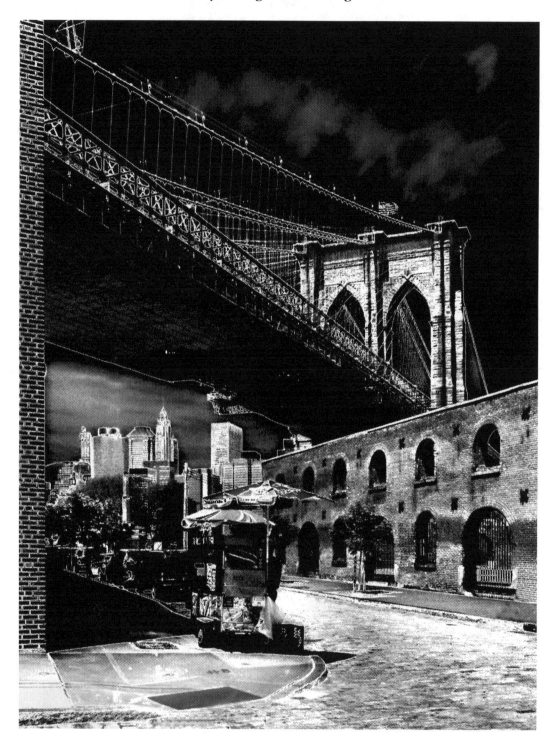

This view of the Brooklyn Bridge just east of the East River is in the DUMBO Section of Brooklyn. Dumbo is short for Down Under the Manhattan Bridge Overpass. The structure on the right is the remnants of an abandoned warehouse. The hot dog stand accommodates the many visitors who patronize the area.

Brooklyn Bridge and Warehouse

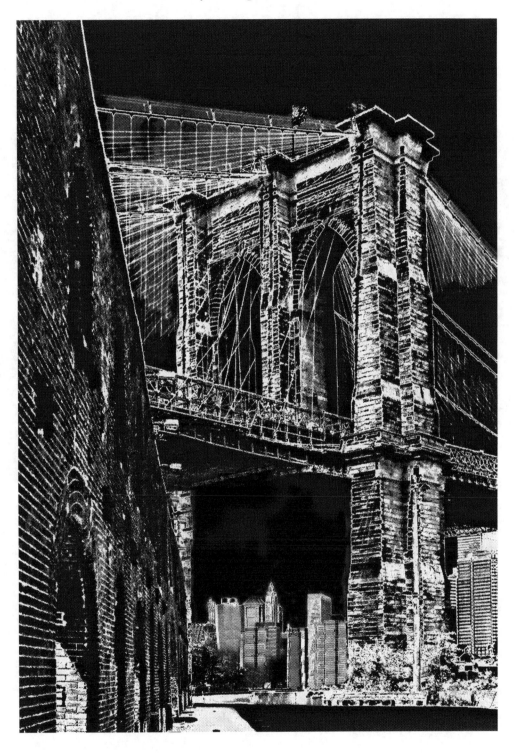

Another view of one of the huge stanchions of the Brooklyn Bridge. The two arches that enhance the all stone stanchion stand as a monument to those who sacrificed their lives in the construction of the bridge. The structure on the left is the other side of the ancient warehouse mentioned in the previous caption of the bridge.

Brooklyn Bridge and Lower Manhattan

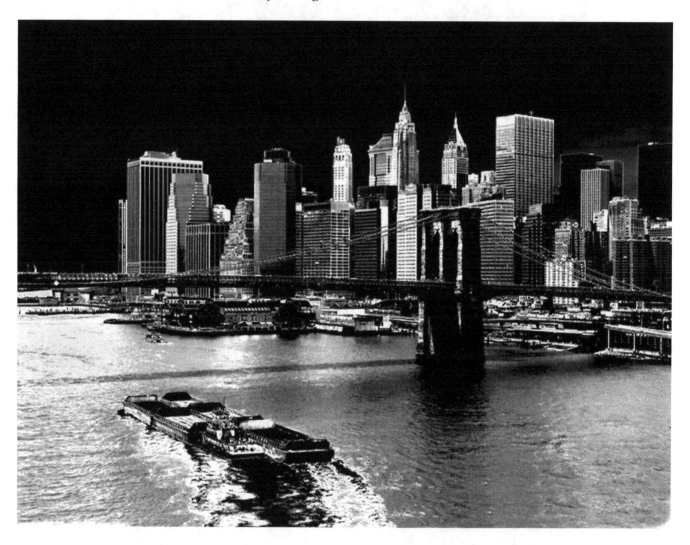

A barge being pushed by a tugboat slowly makes its way under the large span of the Brooklyn Bridge. The skyscrapers of Lower Manhattan act as a dividing point where the East River and Hudson River meet in New York Harbor. This image was taken from the span of the Manhattan Bridge.

Brooklyn Bridge, Another View

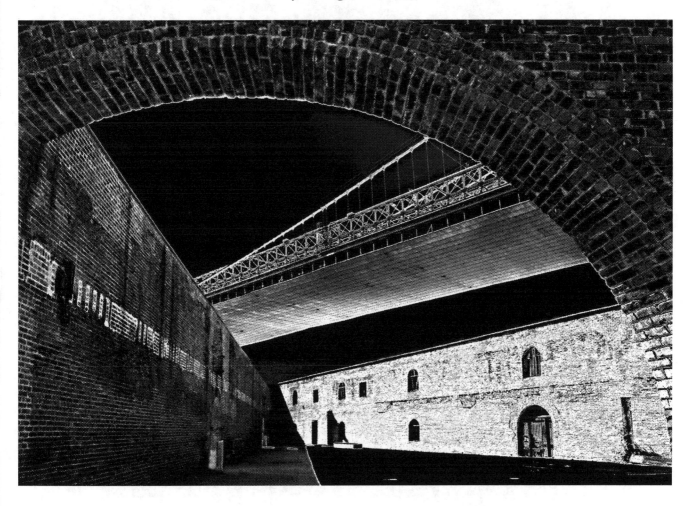

This diagonal partial view of the Brooklyn Bridge Span is seen from just outside the old abandoned warehouse. The two walls of the warehouse meet and are framed by the circular arch at the entrance to the warehouse. This area is a popular tourist attraction and is visited by many people on a daily basis.

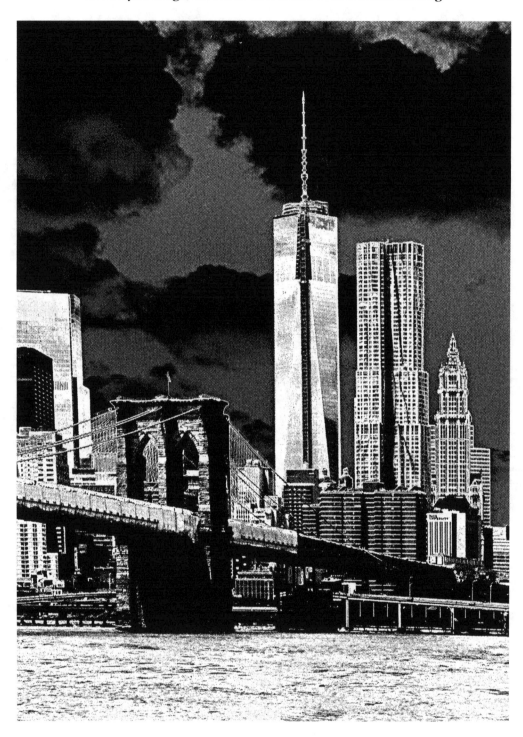

This image is noted for its historic and documentary value. The Brooklyn Bridge was completed in 1883; the Woolworth Building, which is to the right of the three buildings, was the first skyscraper built in New York City, the year was 1913; The Freedom Tower will have been completed in the fall of 2014. The formidable stanchion of the Brooklyn Bridge proudly stands as an entrance to Lower Manhattan from Brooklyn.

Brooklyn Bridge Light Stanchion

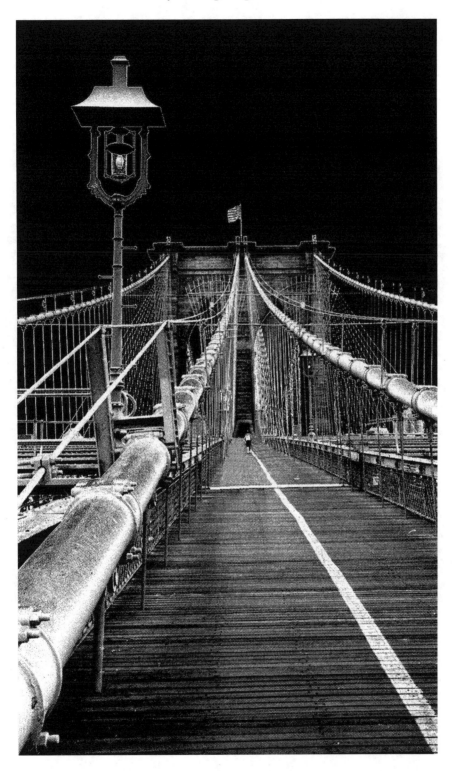

The formidable ancient style light stanchion is in keeping with the age of the bridge that was completed in 1883. Cables aim toward the top of the western stanchion as the pedestrian walk is evident in the foreground as a sole pedestrian calmly walks the length of the bridge.

Brooklyn Bridge Runner

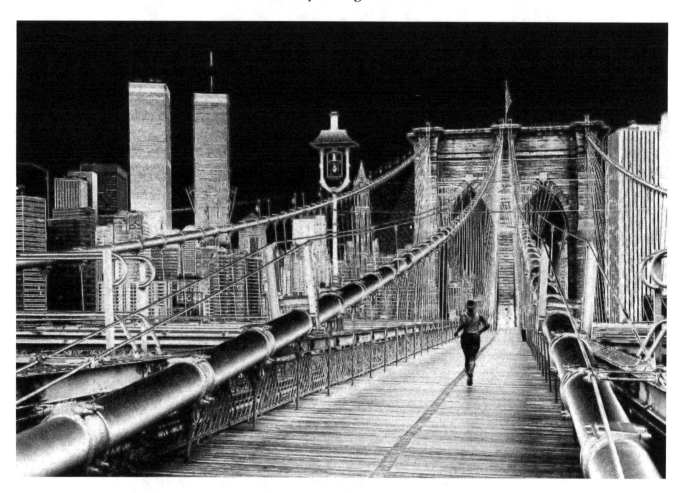

A solo runner takes advantage of the pedestrian walk on the bridge as he works himself to the Manhattan side of the bridge. This horizontal view clearly depicts the twin towers of the World Trade Center that were destroyed in the terrorist attack on 9/11/01. A number of cables are also visible leading to the western stanchion of the bridge.

Brooklyn Bridge Roadway

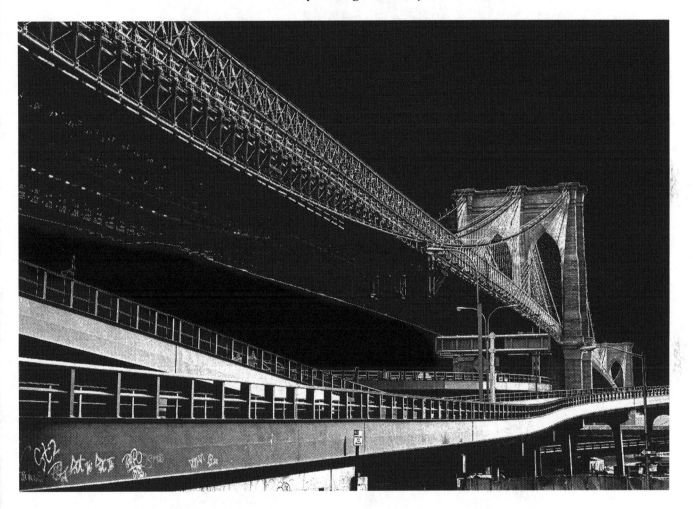

The lower roadway and upper pedestrian walkway aim toward the western stanchion as seen from the Manhattan side of the bridge. The second stanchion can be seen in the distance. There are no trains that travel this bridge, it is reserved for vehicular, bicycle and pedestrian traffic.

Cables on the Brooklyn Bridge

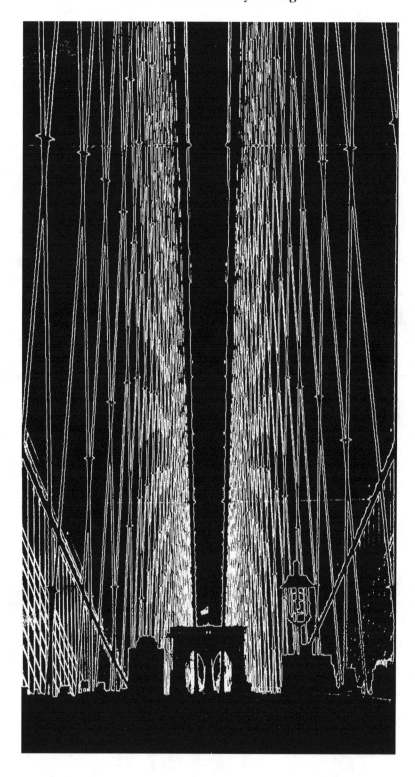

The highlighted cables of the Brooklyn Bridge are offset by the lower foreground silhouette which includes one of the bridge's stanchions and a light stnachion. The long vertical lines give a dramatic presentation to the multitude of cables.

Brooklyn Bridge Cables and Walkway

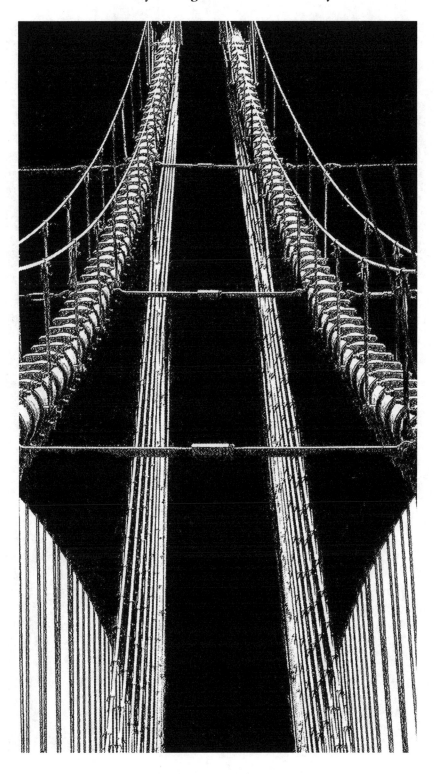

The arches on the lower left and right side of the image are part of the stanchion where the cables and catwalks are attached. The large cables are almost sixteen inches across. Notice the different graphic designs that are formed when simply viewing these cables and the catwalks.

Brooklyn Bridge Cables

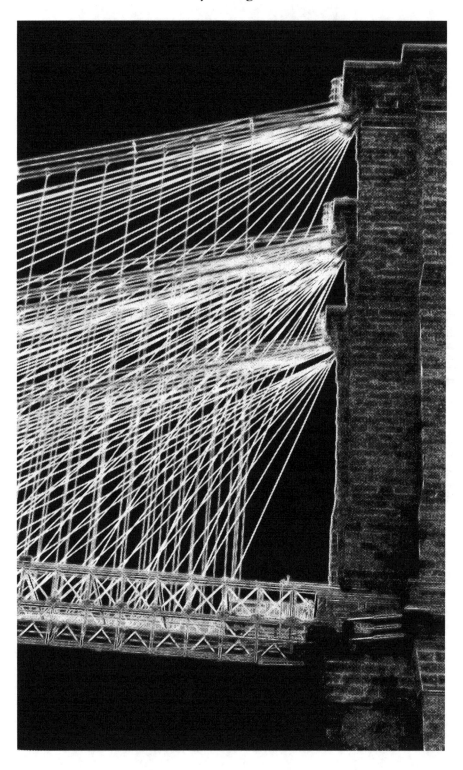

This scene offers the viewer an excellent opportunity to see how the many cables on the bridge are attached to the stone stanchion. This view is from the Brooklyn side stanchion and was captured while on a boat in the East River. Notice the slight gradation in the vehicular path and pedestrian walk.

Manhattan Bridge Stanchion

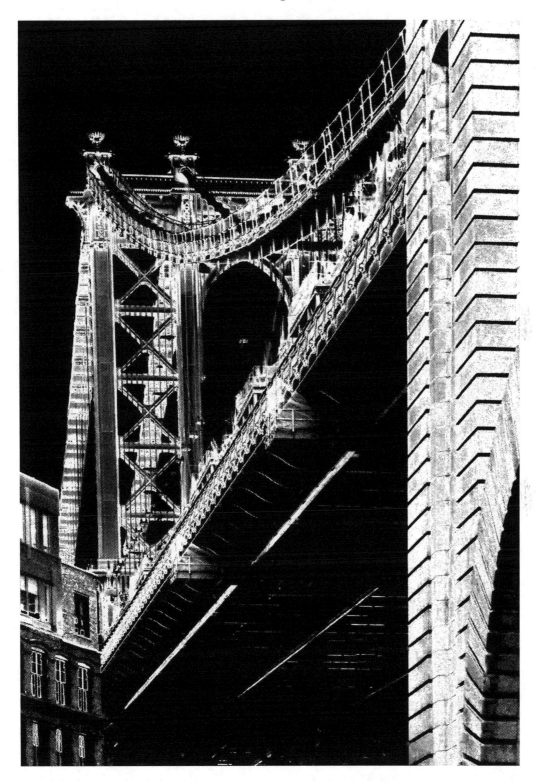

A good look at the large stanchion of the Manhattan Bridge and its roadway. Notice the building on the left that is the Dumbo section of Brooklyn. The metal stanchions contrast the stone stanchions which are prominent on the Brooklyn Bridge.

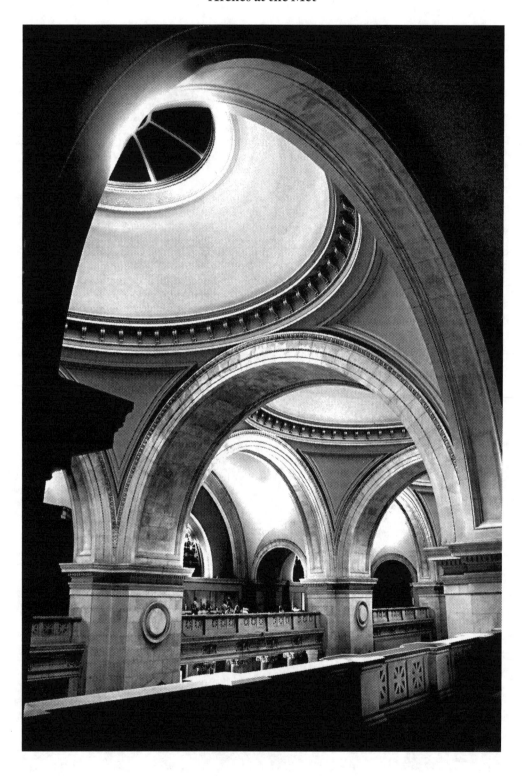

The arches on the ceiling of the Metropolitan Museum of Art comprise the ceiling and are obvious when entering the museum. The entrance foyer is called the Great Hall and was designed by architect Richard Morris Hunt. The joining of these arches on the ceiling forms a unique design throughout the Great Hall. This was a well thought design for the entrance to this beautiful landmark.

Columns at the Met

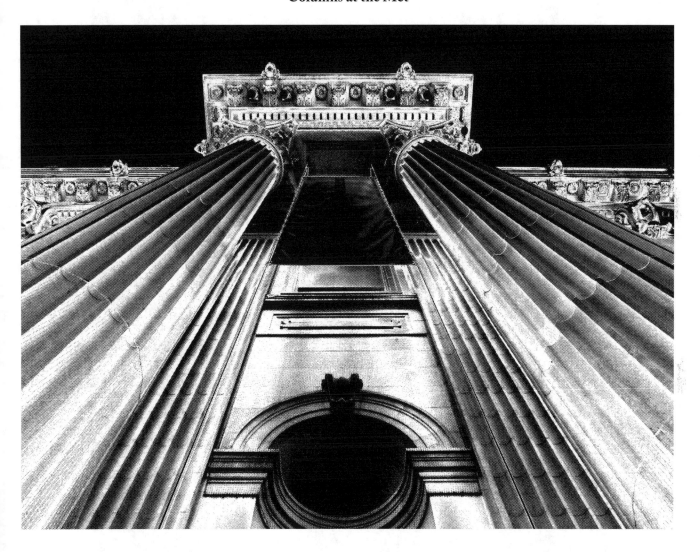

Pictured are two of the eight stately columns that adorn the front of the Metropolitan Museum of Art in New York City. These columns are but a few of the many architectural designs that are prominent in the museum. Their dominating presence are a welcoming sight to the many visitors of the museum.

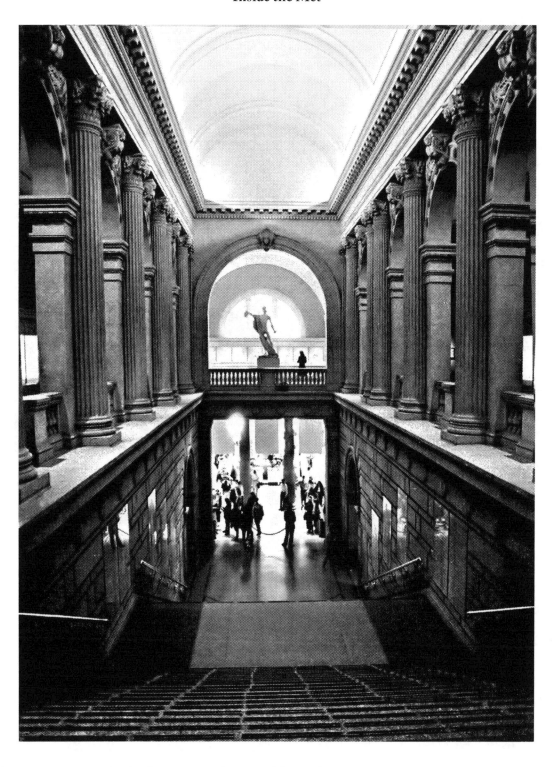

The grand staircase that leads visitors to the second floor of the museum was also designed by Richard Morris Hunt. Notice the alternating square and round columns on each side of the staircase. The center dome and the sculpture at the top of the entrance to the staircase all add to the beauty of this part of the museum.

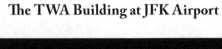

The TWA Building at JFK Airport

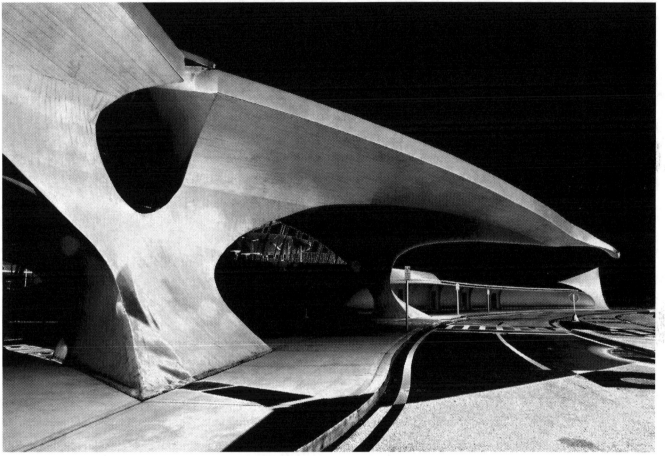

This large ornamental structure is part of the entrance to the TWA Building at JFK Airport in new York. The metal design is reminiscent of the head of a bird with large beak. After having gone through a series of renovations the building has been recently opened to the public.

Wing - TWA Building at JFK

The TWA building JFK Airport in New York was opened in 1962. The wing shaped structure was designed by Eero Sarrinen. The unique interior was a delight to behold by the many people who at that time flew TWA. The name of the airport at that time was Idlewild. The large window was part of the unique design.

JFK Tram

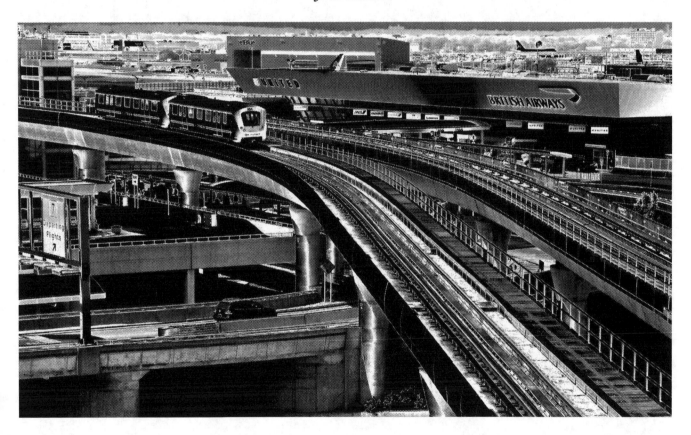

The two car trams operate at JFK Airport to service passengers and guests among the various airline terminals that service the airport. There is also a direct service to the Jamaica Long Island Railroad station for a nominal fee.

JFK Tram Station entrance

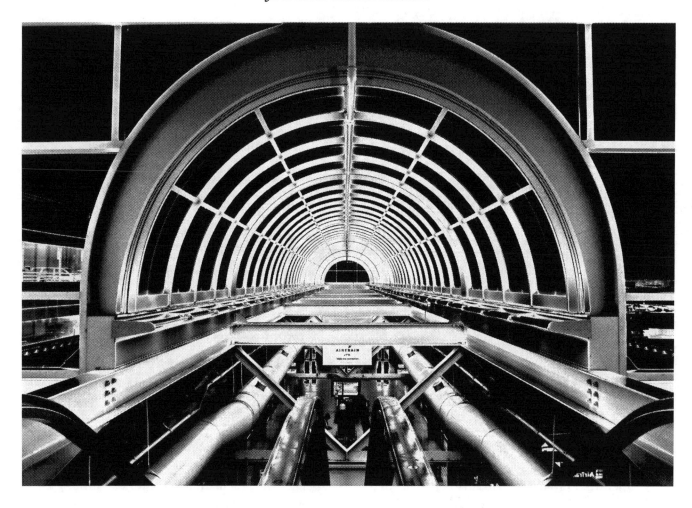

This tram station is directly connected to the Jet Blue Terminal at JFK Airport. The two vertical lines in the center foreground are the handrails of the escalator that lead directly to the station platform below. Notice the semi-circular design enhancing the entrance.

JFK Tram Station

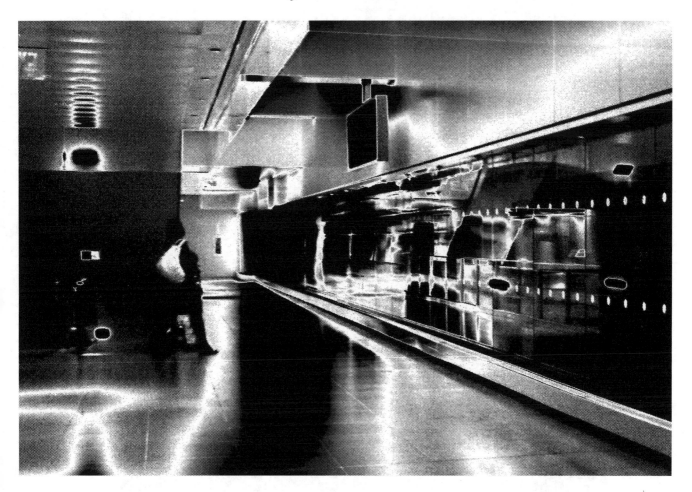

A lone pedestrian stands by with a bag on his back watching a tram leaving the station. This particular station is entirely covered. Some tram stations at JFK are covered and some are not.

A view from the second floor of the 42ⁿᵈ Street Library which is also known as the Stephen A. Schwartzman Building, showing the majestic staircase, arches and columns that enhance this beautiful structure. The library houses 88 miles of shelves with an additional 40 miles under neighboring Bryant Park and has 15 million volumes in its stacks. It is primarily a research and resource center.

Empire State Building

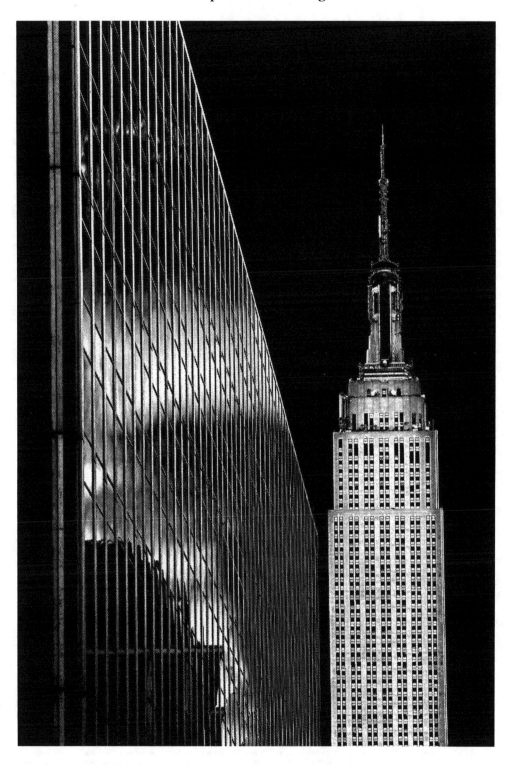

Construction of the Empire State Building took just thirteen months and was completed in 1931. With its 102 stories it was the tallest building in the world for almost forty years. More than 110 million people have visited the observation deck on the 86th floor where they have a panoramic view of New York City.

Flatiron Building

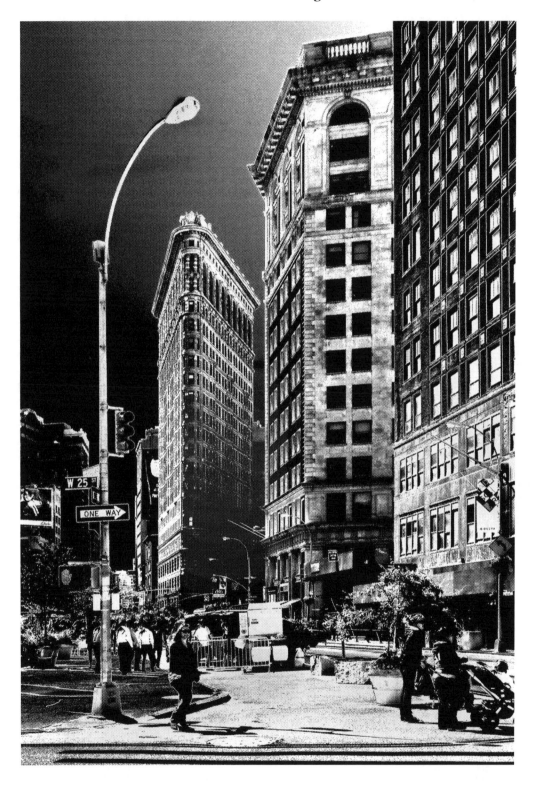

Looking south from Broadway and framed by a light stanchion on 25th Street, the Flatiron Building retains its historical significance as one of the first skyscrapers in New York City. The triangular design was unique and still draws the attention of many tourists and native New Yorkers.

Flatiron Building and Gables

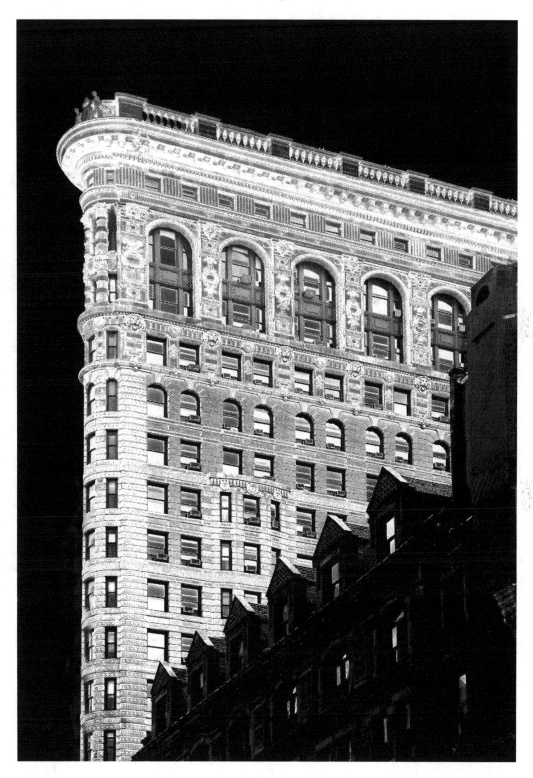

Another view of the Flatiron Building from 6th Avenue. The building was constructed in 1902 and stands 22 stories tall. Notice the gables from a neighboring building as they add a gaphic dimension to a view of the building.

Circular Building

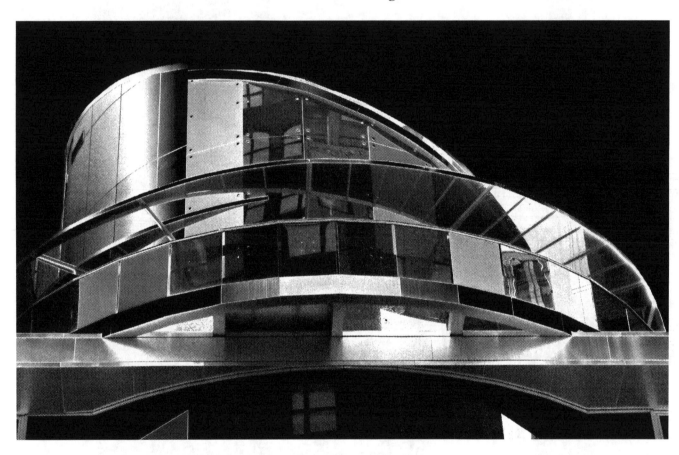

This circular building that rests on a horizontal plane is located at the Avenue of the Americas in the upper 30s in News York City. Notice the variation in tone where the upper circle intersects the circle just below and the tonal variation in the glass of the lower circle. The change from white to black through various tones of gray offer a distinct variation and is typical of the solarization process.

Grace Building

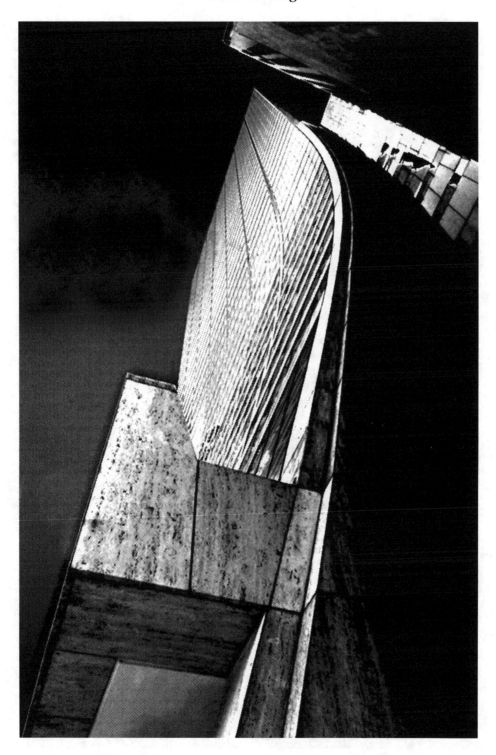

The Grace Building is located on 42nd Street near 6th Avenue. Looking straight up, the natural curve is quite obvious. The building actually gets thinner as its height increases. The concave design indicates a vertical slope on to both sides, 42nd and 43rd Street of the building. The architect of this unique design was Gordon Bunshaft.

Bank of America Tower

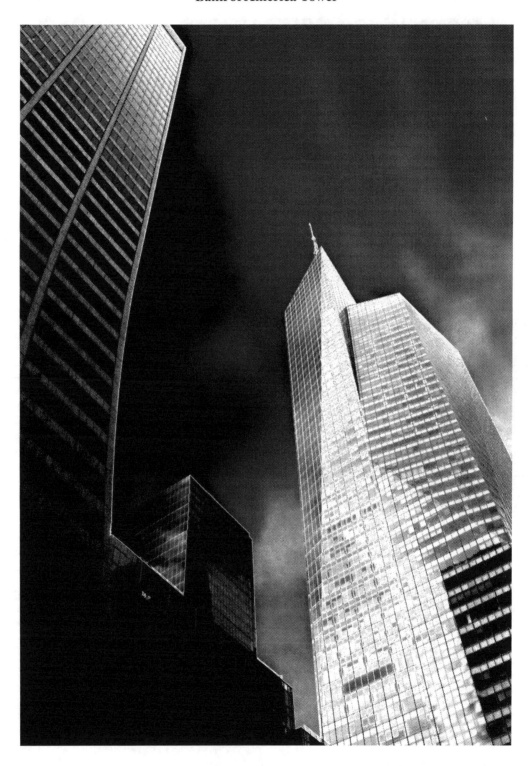

The Bank of America Tower is the third largest building in New York City after the Freedom Tower and the Empire State Building. Its construction was completed in 2009. This image was taken from 43rd Street and the concave slope of the Grace Building can be seen on the left side.

World Financial Center

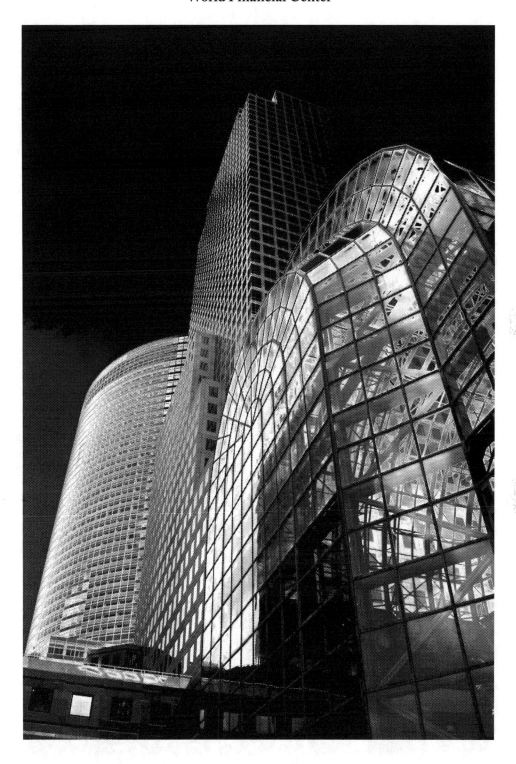

Now known as Brookfield Place. The World Financial Center has undergone years of renovation due to the damage that was done during the attack of the Twin Towers of the World Trade Center. The western section of the glass domed circular design overlooks the Hudson River. It is the home of many corporate offices and was originally designed by Cesar Pulli of Adamson Associates.

IAC Building

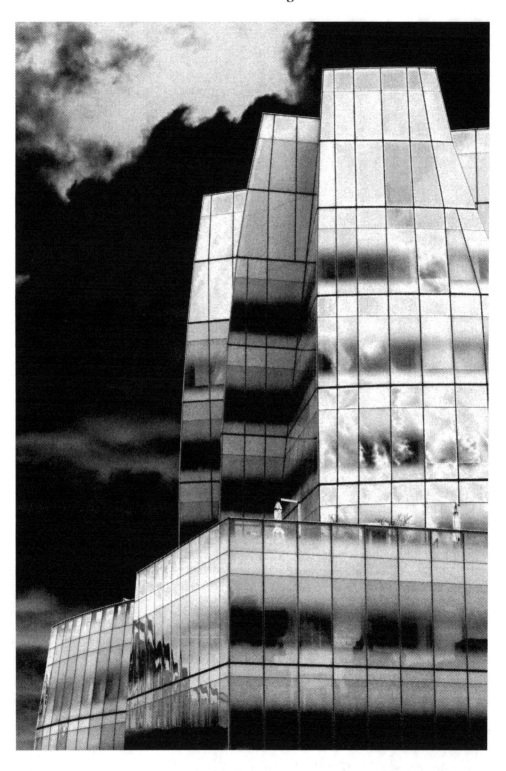

The unique design of this building was created by Frank Gehry. The building was completed in 2007. It is located in the Chelsea Area of New York City adjacent to the West Side Drive and overlooks the Hudson River. The outer part of the building is all glass supported by an inner concrete structure.

Residential Building at High Line

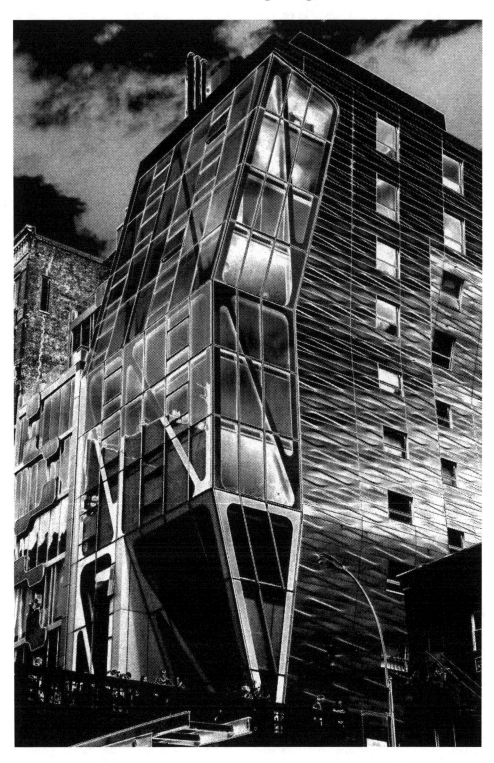

The design of this residential building is eye catching. The glass front and side that rises in three sides form a triangle base to a three part vertical rectangle to a four part diagonal rectangle. This building is parallel to the High Line in the Chelsea Area of New York City.

Arches at Randalls Island

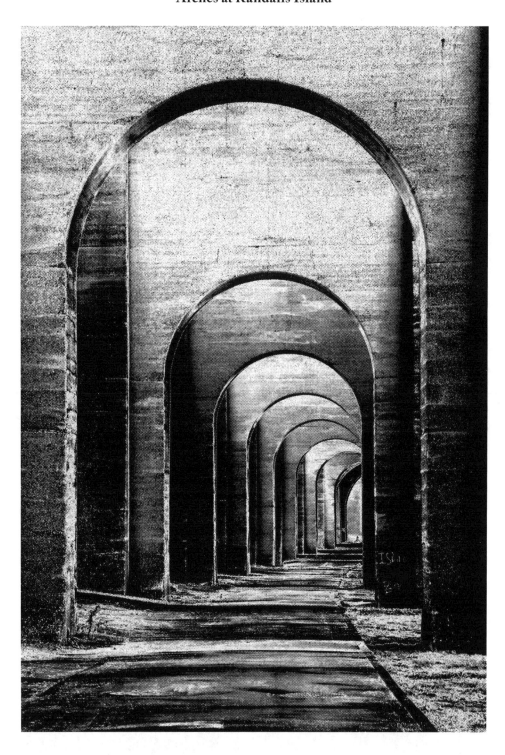

Randalls Island is located in the East River between Manhattan, the East Bronx and Queens. It is easily accessible from the Robert F Kennedy Bridge. The arches seen here act as a viaduct for the Northeast Railroad Corridor, Amtrak route between New Jersey/New York and New York Connecticut state lines, New York, New York County, New York. The island is well known for its sports facilities and has many very active participants.

Column and Disc

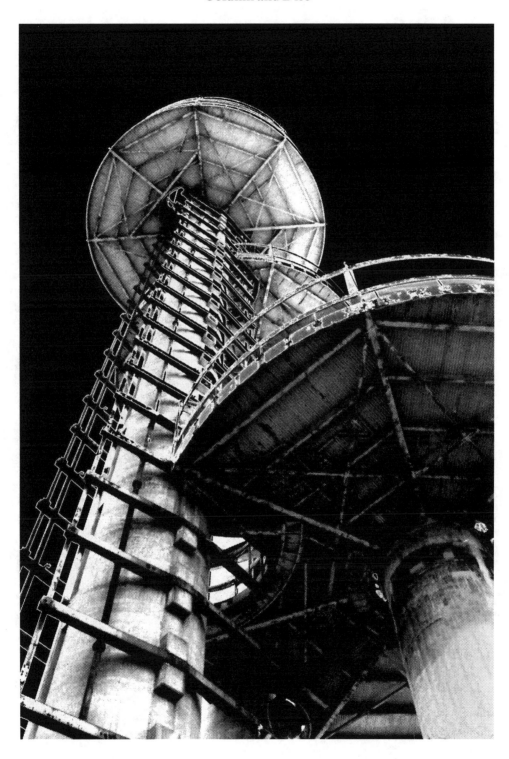

This Column and Disc was the New York State Pavilion in the 1964 Worlds Fair. It is located in Flushing Meadow Park, Queens. In 2009 it was listed on the National Register of Historic Places. It was used in the TV series McCloud and for the movie Men in Black. Plans are now underway to restore the structure.

Unisphere

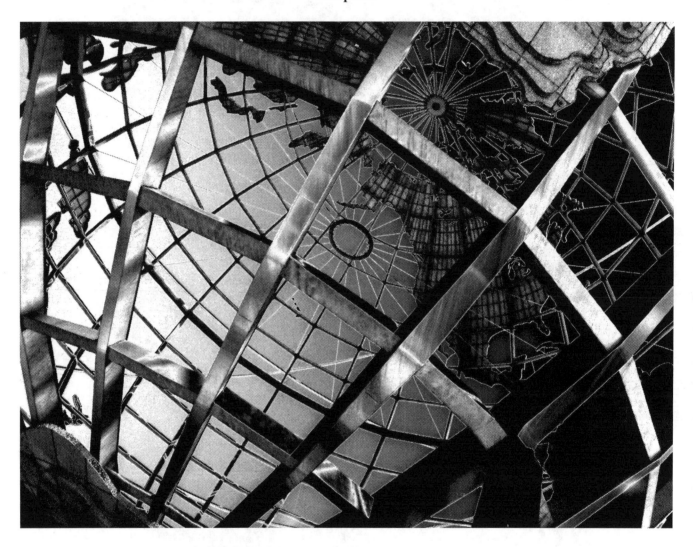

The Unisphere was prominently featured in the 1964 World's Fair. It was the object symbol of the fair and still adorns the fair site in Flushing Meadow Park in Queens of New York City. It was featured in the movie Men in Black. The image seen here is only a small portion of the lower portion of the Unisphere. It is complimented by a pool and shooting water display. The unisphere is twelve stories high and constructed of stainless steel.

Guggenheim Museum

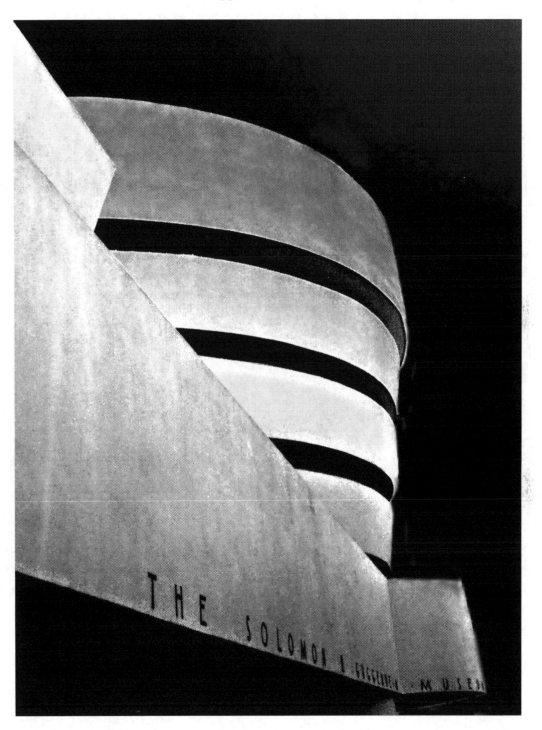

The Solomon R. Guggenheim Museum was designed by Frank Lloyd Wright and opened in 1959. The unique cylindrical shape starts small at the bottom and gradually gets larger as it rises. This compliments the interior ramp that gradually rises so guests may view the art works at various levels of the museum. The concept was to have the viewing areas flow from one venue to another.

Guggenheim Ceiling with Calder

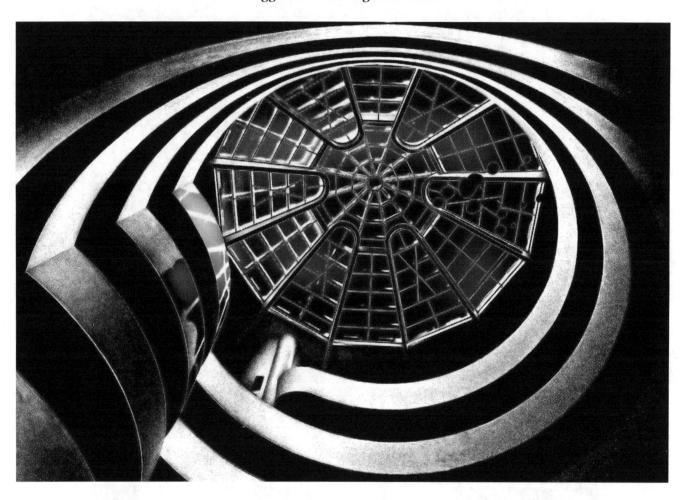

Looking straight up from the ground level of the museum the walls of the ramp are clearly outlined and from the lower portion of the image the convex outline can be seen. The ceiling is glass designed in triangular sections and to the right in the ceiling are pictured black discs with white outlines. This is the Caldor Sculpture which is actually white but the tone is reversed in the solarization process.

Pennsylvania Station

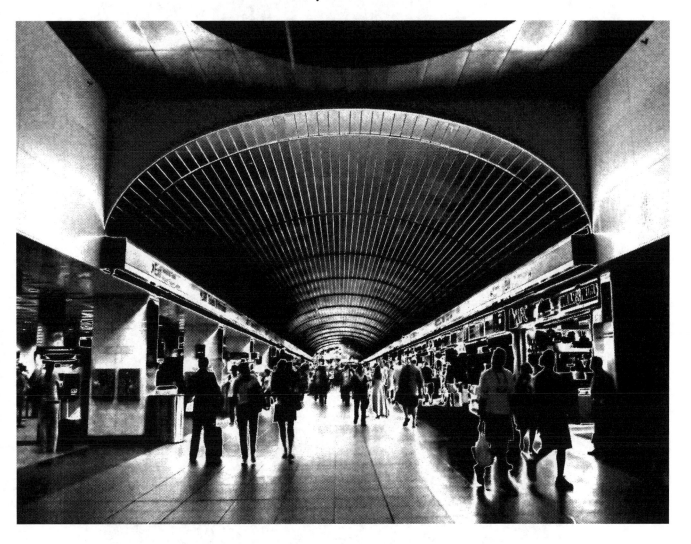

Looking toward the north end of the promenade the semi circular dome dominates the area. To the right of the promenade are shops and eating places and on the left is the entrance to the tracks of the Long Island Railroad where thousands of commuters enter and exit on their daily commute.

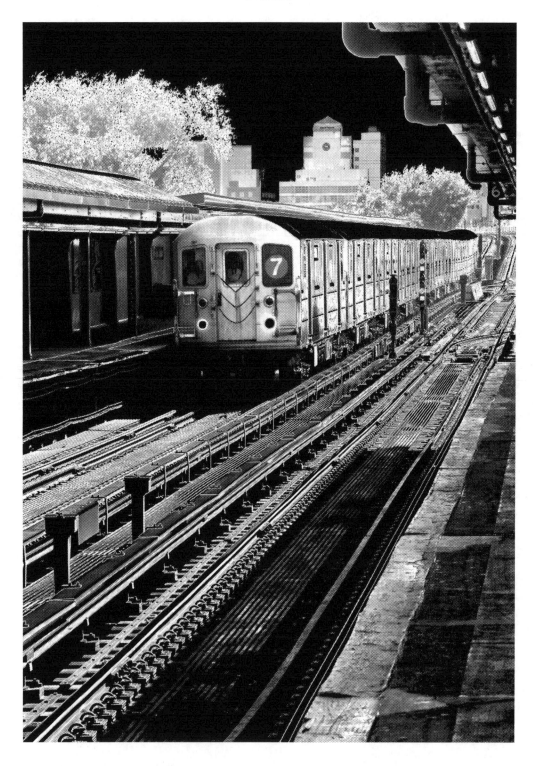

The 7 Train is the favorite mode of transportation to Citi Field to see the Mets or to Arthur Ashe Stadium for world class tennis. It is also the daily route for residents of the Flushing area of Queens for their daily trek to their chosen fields in Manhattan. This is a very popular subway line.

Twin Towers at the World Trade Center

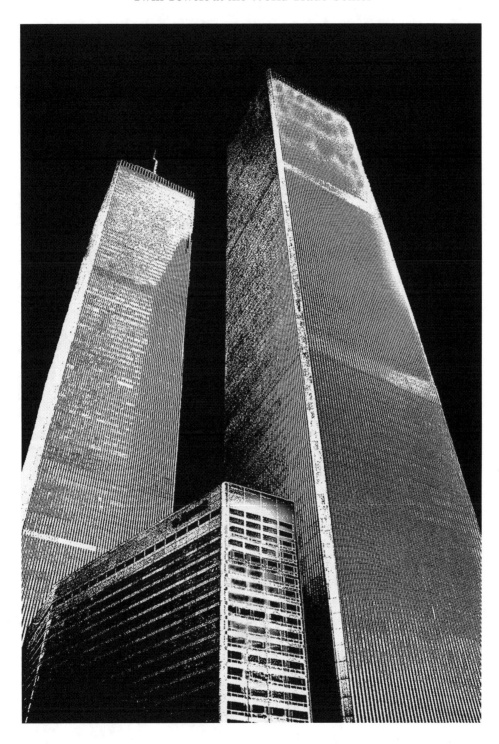

The twin Towers of the World Trade Center were composed of a north and south tower. There were indoor and outdoor observation areas on the 109th and 110th floors. The towers were destroyed on 9/11/01 by an Alqaeda terrorist attack. The buildings were officially open in April of 1973. 50,000 people worked in the towers and the towers were so large they had their own zip code, 10048.

PART 2

INTERESTING AND HISTORICAL SITES

Some of the interesting and historical sites that are represented are the University of Tampa, Florida Southern College and The Florida Museum of Photographic Arts. Many of the buildings at Florida Southern College were designed by Frank Lloyd Wright. The University of Tampa was formerly the Tampa bay Hotel and was built by Henry B. Plant. It became Tampa University in 1931 and is unique because of its Moorish Revival Architecture. Their college newspaper is called the Minaret.

In close proximity to Tampa University, right across the Hillsborough River is The Florida Museum of Photographic Arts and that museum is housed in a building called "The Cube" because of its unique architecture. Teddy Roosevelt stayed at the Tampa Bay Hotel with his Roughriders before going to Cuba to fight in the Spanish-American War. Also included in this section are some photos of the Dali Museum in St. Petersburg, Florida. The unique design of this building both inside and out is certainly within keeping of the wonderful surrealistic art work of Salvatore Dali that is found inside this building.

A few more other interesting sites will be seen in this section including Coindre Hall and The Phipps Mansion.

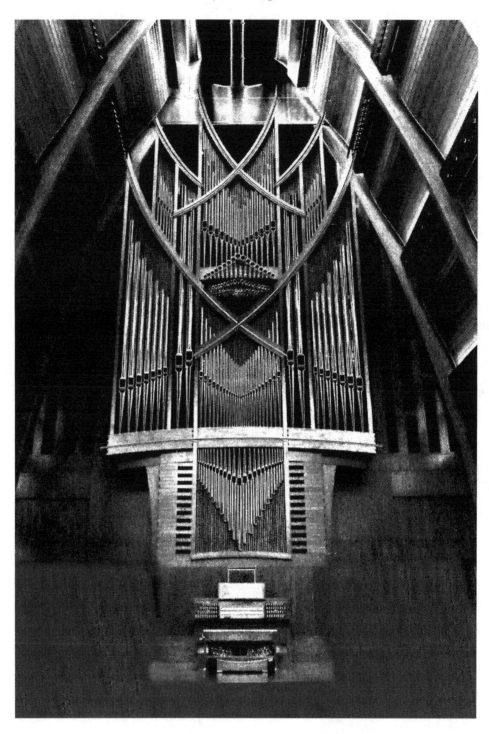

Known as the Sykes Chapel and Center for Faith and Value at Tampa University, this chapel was designed as a meditation center for all faiths. The development of character and values was a commitment made by the university to its students with the construction of this chapel. Two praying hands outline the design of the building. Natural lighting was an important consideration when designing the chapel and the materials of cherry wood and glass compliment this concept.

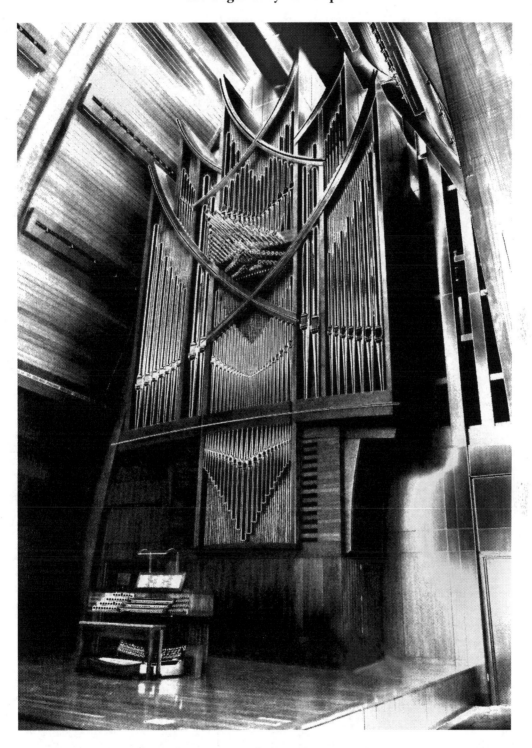

The casework of the pipe organ is 55 feet high and has 3184 pipes. It has a mechanical key action and was designed by Dobson. The pipes that cannot be seen and that are hidden from view are housed in a three story room in the rear of the chapel. In addition to serving as a place of meditation the chapel also serves as a recital hall where many concerts are given.

Leepa-Rattner Museum

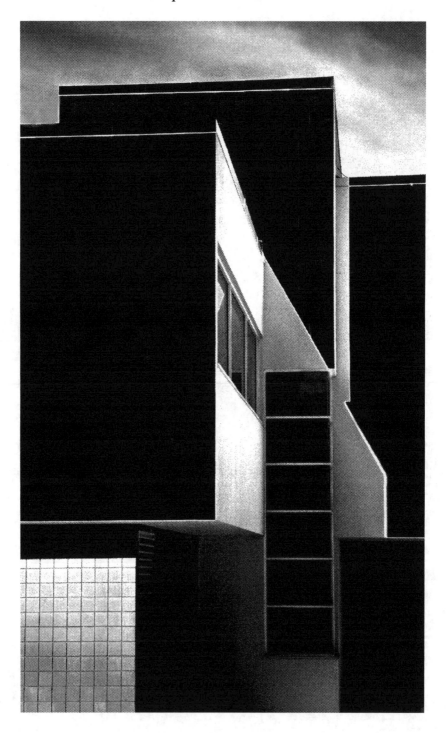

The Leepa-Rattner Museum was designed by Edward C. Hoffman for which he received an award of excellence by the American Institute of Architects. There are many lines and graphic designs that are prominent in this image of the Leepa-Rattner Museum. The diagonal lines are offset by the vertical and horizontal lines. The rectangles within rectangles and squares also add to the interest of this graphic design.

Annie Pfeiffer Chapel

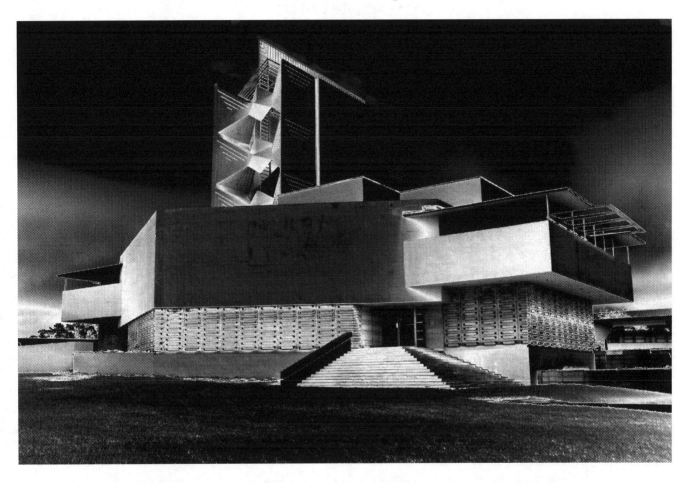

Many buildings on the campus of Florida Southern College were designed by Frank Lloyd Wright. The Annie Pfeiffer Chapel is one of the nine buildings designed by Frank Lloyd Wright for Florida Southern College and the first to be dedicated. The year was 1941. The Princeton Review listed Florida Southern College as the most beautiful campus in America in 2011. It is also listed as a historic district in the National Register of Historic Places.

Annie Pfeiffer Skylight

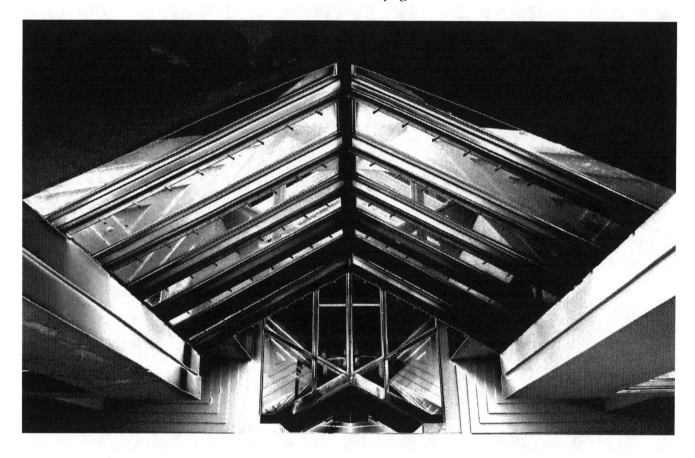

The skylight of the Annie Pfeiffer Chapel was designed with the concept of having as much natural light entering the chapel from the top of the building as possible. The triangular design rests on top of two large concrete slabs. These concrete slabs contain colored glass that reveals blue, red and amber on a sunny day. Because of its unique design, as can be seen from the previous photo, it is sometimes referred to as the bicycle rack.

Minaret at Tampa University

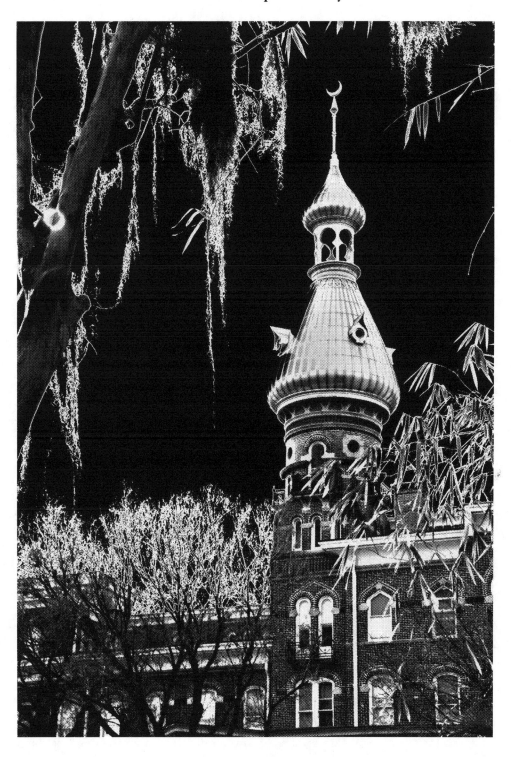

The Moorish style architecture of Plant Hall, the main building on the campus of Tampa University, dates back to 1891 when it was known as the Tampa Bay Hotel. It is located in downtown Tampa Florida and also houses the Henry B. Plant Museum. It is said that Teddy Roosevelt and his Rough Riders stayed at the hotel before going to Cuba to engage in the Spanish American War.

Florida Museum of Photographic Arts Lobby

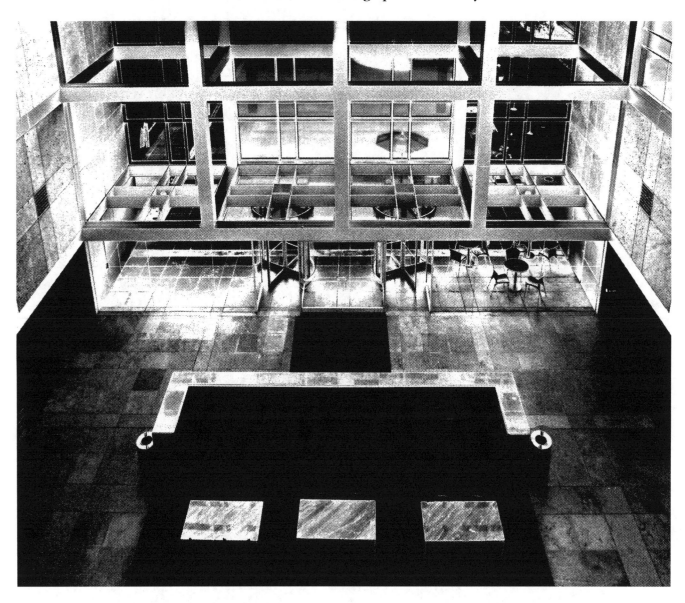

The Florida Museum of Photographic Arts is housed in a building called The Cube at Rivergate Park in Downtown Tampa, Florida. The square blocks that comprise the walls offer a unique design. Pictured here is the lobby as seen from the second floor. The three squares in the foreground are actually tables as there is a snack bar out of sight to the right. The large squares that comprise the outer wall are usually adorned with pictures of celebrities.

Wall at the Cube

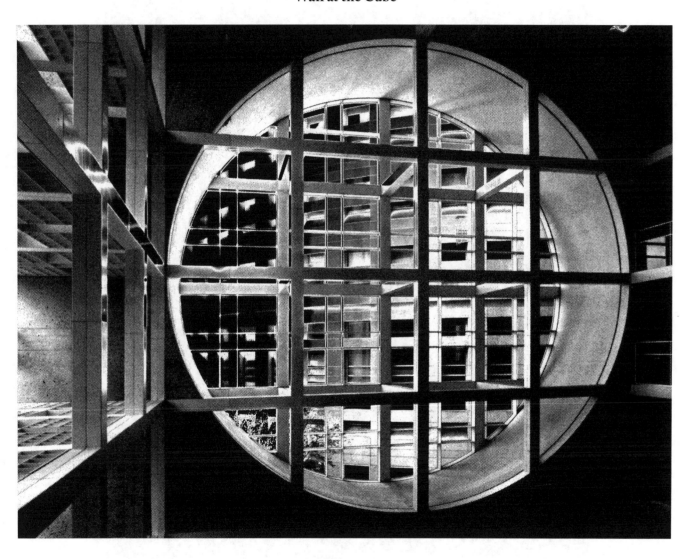

This circular design with its crossing horizontal and vertical beams is the wall that adorns the Florida Museum of Photographic Arts in the building known as The Cube. Notice the crossing beams on the left that tend to join the circle.

Dali Museum Sculpture

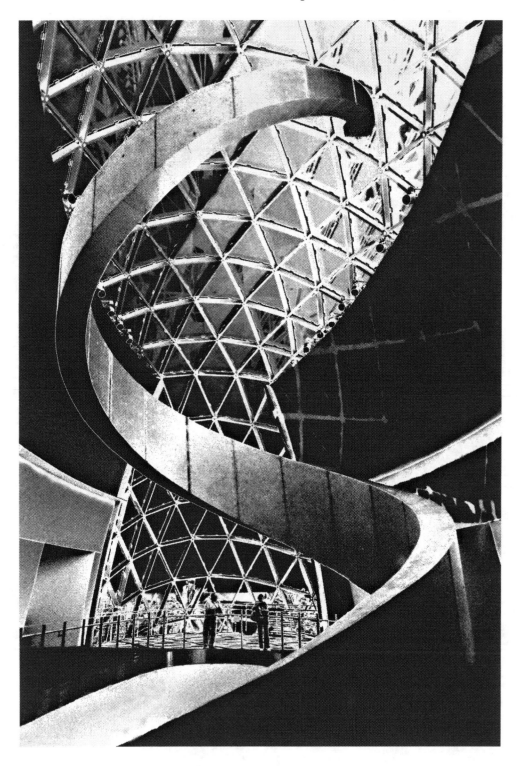

The two people on the deck of the third floor illustrate the perspective of the spiraling sculpture that aims for the ceiling in the Dali Museum. In the background are parts of the 1062 glass triangles that are an integral part of the architecture that was designed by Yann Weymouth. The outer concrete walls are 18" thick and serve as protection for the Dali artwork from the threat of hurricanes.

Dali Museum Eggshell

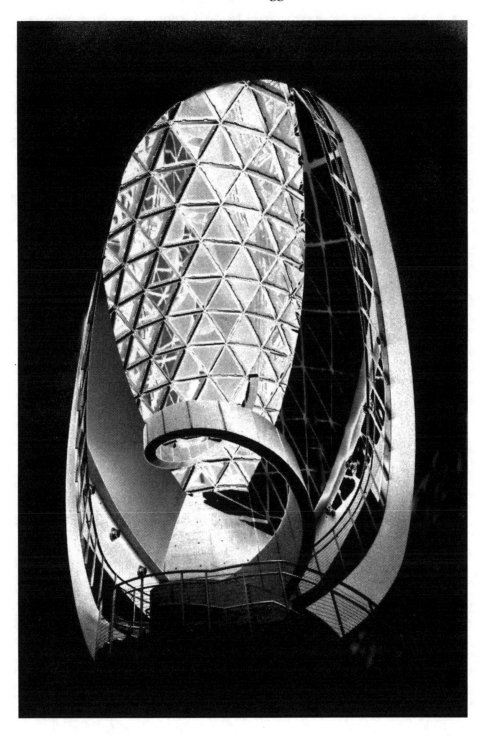

Displayed is a full view of the upper portion of the Dali Museum that forms an eggshell type design. The museum houses the largest collection of Dali's work outside of Europe. The glass triangles that extend through the outer part of the building are called The Enigma. The shadows formed by the Enigma reflect interesting and contrasting graphics and designs on the walls in the upper part of the museum.

Staircase at Coindre Hall

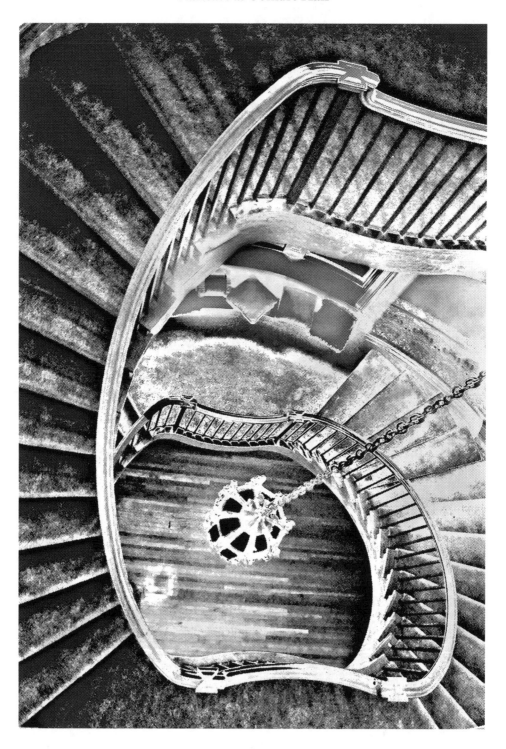

Coindre Hall was originally constructed for George McKesson Brown in 1912. He lost his mansion in the stock market crash of 1929. The staircase with its beautiful chandelier hanging from the ceiling is the centerpiece of this 40 room mansion. It is occasionally used for weddings and is now administered by the Suffolk County Department of Parks in New York State. Notice the sofa and pillows as a resting place for those so inclined.

Boathouse at Coindre Hall

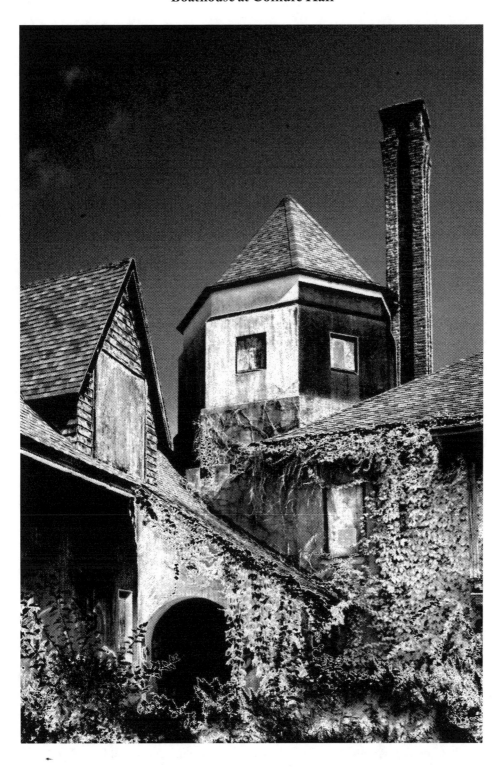

The boathouse rests adjacent to Huntington Harbor in the town of Huntington, New York. It is part of the Coindre Hall complex. The design is similar to the old French Chateau with its pointed roof and arched entrance. It has not been used for many years as evidenced by the overgrown foliage. Notice the tall chimney and the boarded window.

Window and Chair

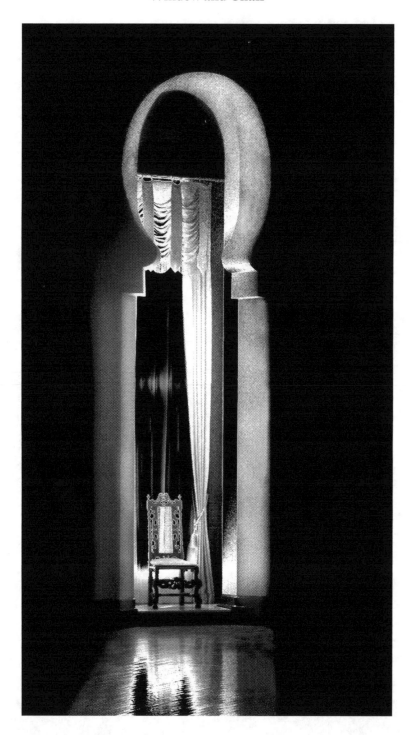

The room that houses this window and chair is part of Tampa University and formerly the Tampa Bay Hotel. The hotel was constructed by Henry B. Plant in 1888. This room could have been the casino of this great hotel that is located adjacent to the Hillsborough River. Plant chose the Moorish Revival architectural style which is evident when viewing this massive window. This room with its domed ceiling is now used for conventions and concerts.

Tampa Museum of Art

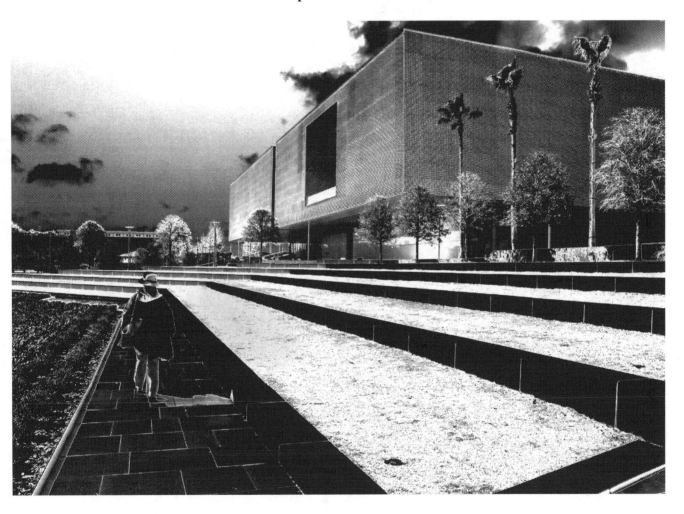

The leading diagonal lines in the foreground of this image direct the viewer to the front of the museum. The perforated aluminum walls are ever present both inside and outside the museum. There are fiber optic lights on the outside walls of the building which offer different colors in lighting the building at night. The new building that now houses the museum opened in February of 2010 and is situated next to the Hillsborough River in Curtis Hixon Park.

Alcove at Tampa Museum of Art

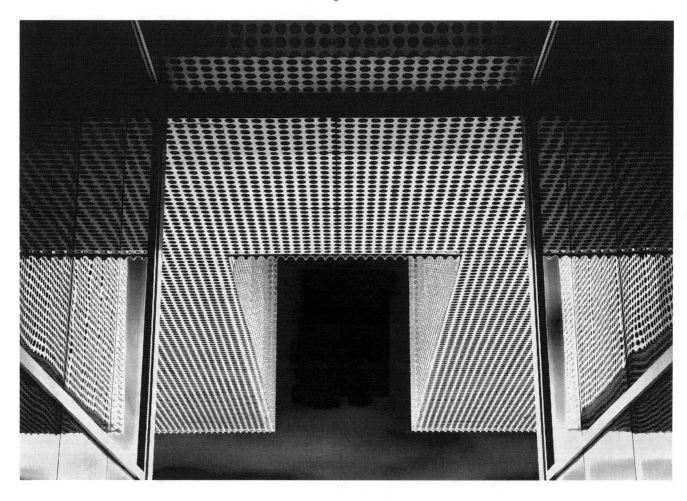

From inside this small alcove that adjoins the Tampa Museum of Art one can see the sky, the perforated aluminum that is present throughout the museum inside and out and the reflection of the perforated aluminum in the glass panels. The darker reflections are also noticeable in the upper portion of the image. The symmetrical design of the triangles, vertical, horizontal and diagonal lines also add interest to this image.

US Federal Building and Courthouse

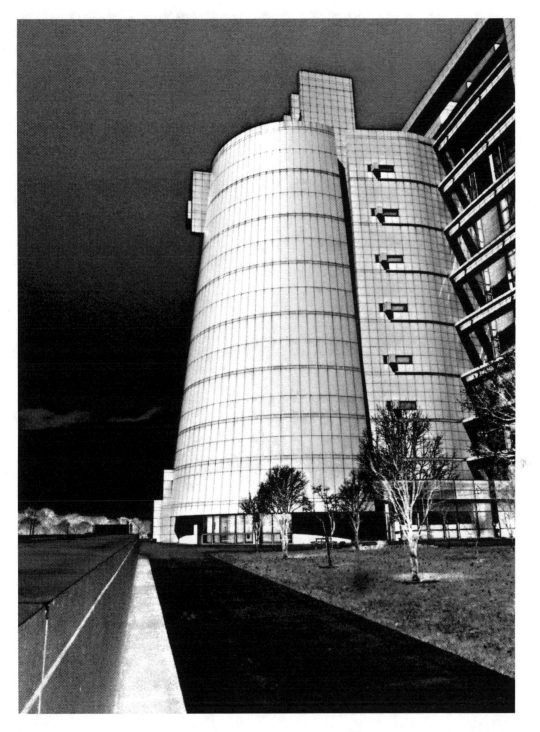

The official name of this building is Long Island Federal Courthouse. The alternate name is Senator Alfonse D'Amato Courthouse. The cone shaped structure is the entrance to the 12 story building. The main portion can be seen on the right and extends on both sides of the rotunda. The building is located in Central Islip, New York just north of the Southern State Parkway.

Phipps Mansion

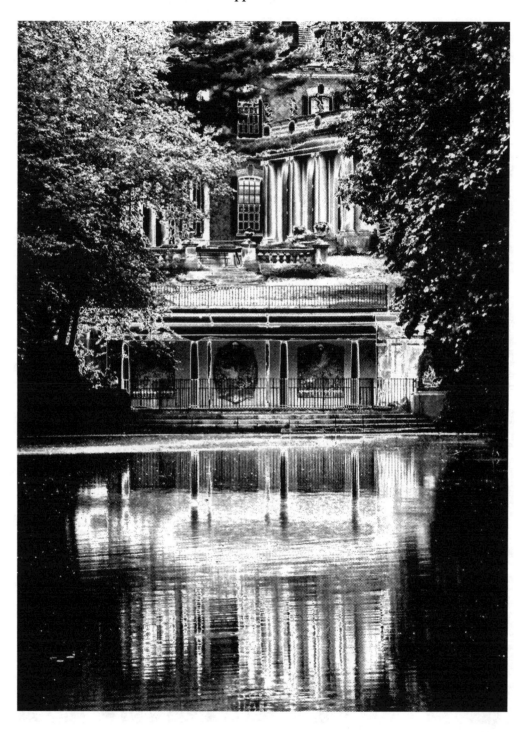

The Phipps Mansion is located at Westbury Gardens in Old Westbury, New York. The house was completed in 1906 and was designed by George A. Crawley. Notice the pillars that are constructed in the Charles II style. The lake with some pillar reflection is in the foreground. A gazebo named "The Temple of Love" is on the far side of the lake. The area is noted for its beautiful gardens and foliage. Portions of the move "Love Story" was filmed in the mansion.

PART 3

GRAPHICS AND DESIGN

The solarization process lends itself very well to graphics and various designs. The lines appear to be more indelible and easier to read than the conventional monochrome image and more concentration may be put on enjoying the graphic.

Whether the subject be squares, triangles, rectangles, etc. the image usually is clearly defined. The leading lines also tend to show the viewer to the correct destination of the subject. The many intersecting lines and graphics also add to the interest of viewing this type of photography.

The vertical lines tend to be somewhat bolder and the horizontal lines more passive while the diagonal lines usually show direction and the curved lines offer a feeling of peace and tranquility.

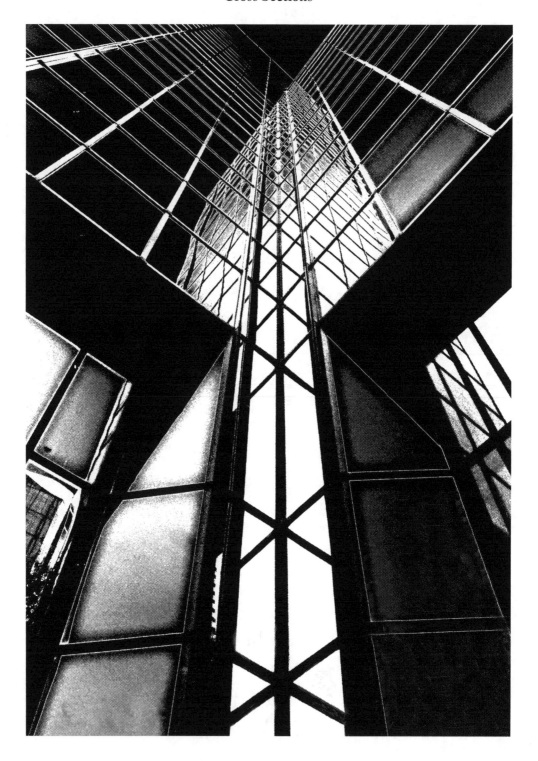

These graphic designs tend to be reaching higher and higher. Starting with a simple design in the foreground the image gets more complex as it rises. The image is in two parts. The bottom portion acts as a support with its broad diagonal lines that support the more complex crossing sections that dominate the top part of the image. The many triangles and rectangles are formed by the dominating diagonal lines.

Crossbeams

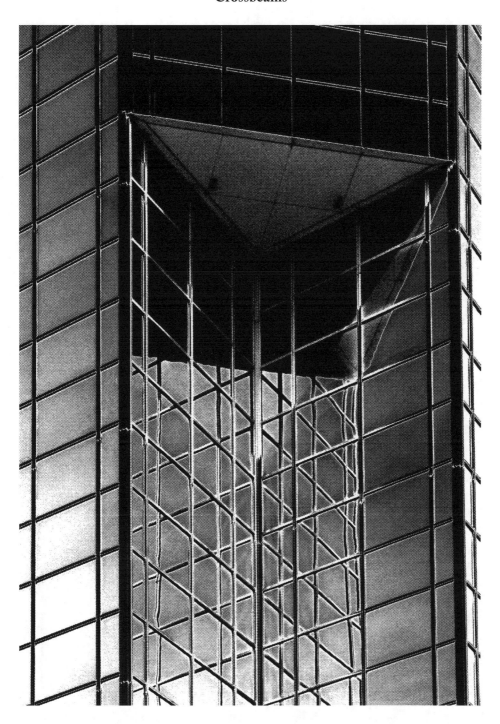

The crossing lines in the center add many graphics to this image as opposed to the other edges and top where the simple graphics dominate. Because the vertical lines offer a firm foundation, this design tends to be somewhat more stable than the previous example. The change of tone from light in the lower left corner to the black near the center top that washes away some of the lines add contrast to the image. Notice the triangle that is formed in the area just above the black portion of the picture which has no lines except the natural tonal changes.

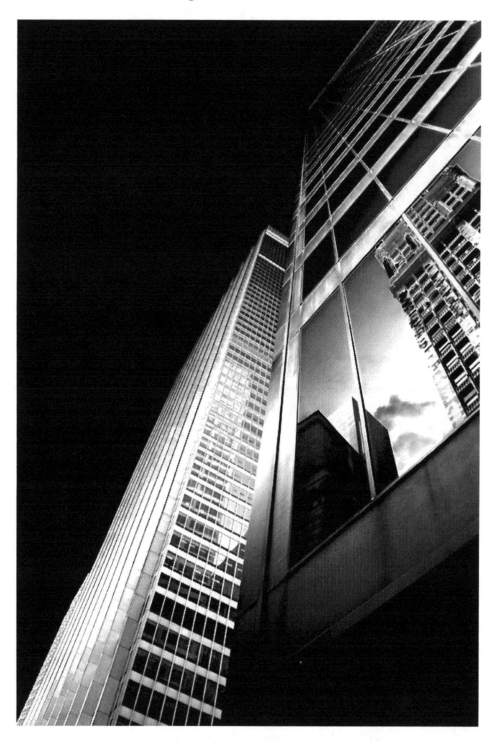

There are two skyscrapers that comprise this image and three if you include the reflection of the building on the right side. The contrast of the size of the rectangles, smaller in the building on the left and larger in the building on the right, add to the interest of this picture. The diagonal lines starting with the line in the lower left hand corner tend to lead the eye to the apex on top of the building and then to the adjoining building.

Building Gradation

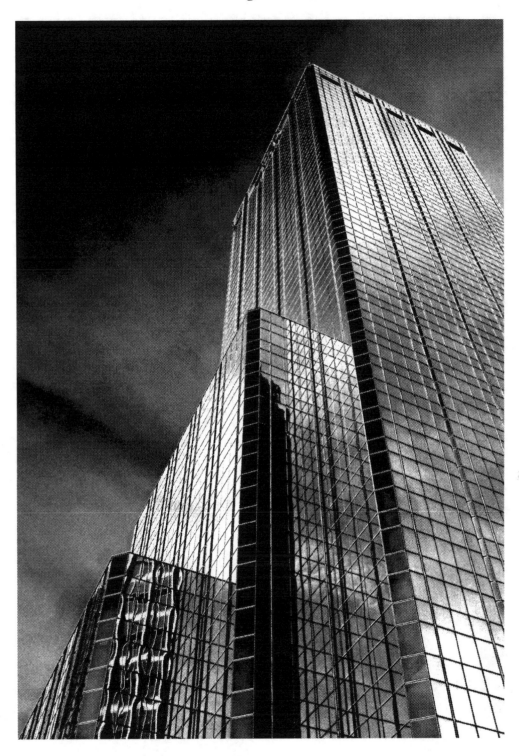

As can be plainly seen, the gradual ascension to the top where the triangle is formed starts with the lower portion of the building and grows to the next portion and then finally to the large part of the skyscraper. Most graphics in this image are uniform except for the slight distortion caused by the reflection in the lower left corner.

Reflective Building

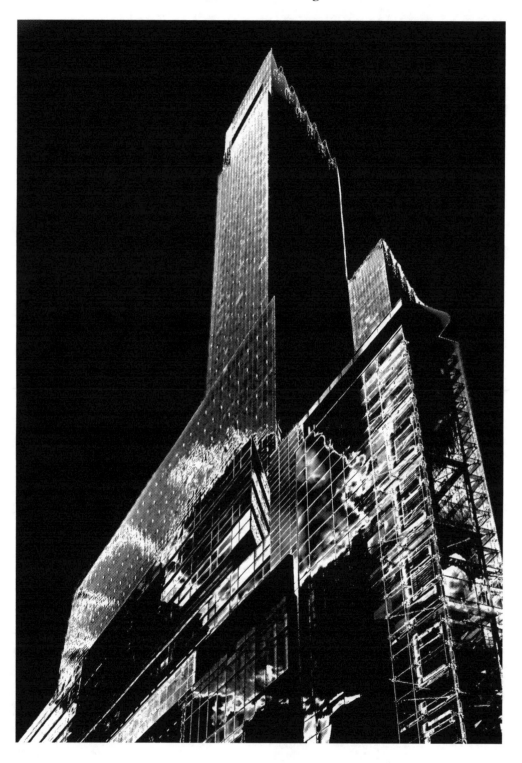

The crossing vertical and diagonal lines tend to suggest a somewhat powerful structure topped off with triangles on the upper portion of the building. The black sky instills a dramatic effect into the image. The black part of the building outlined in white is interrupted with a reflection of the unseen natural sky.

Eternal Flame

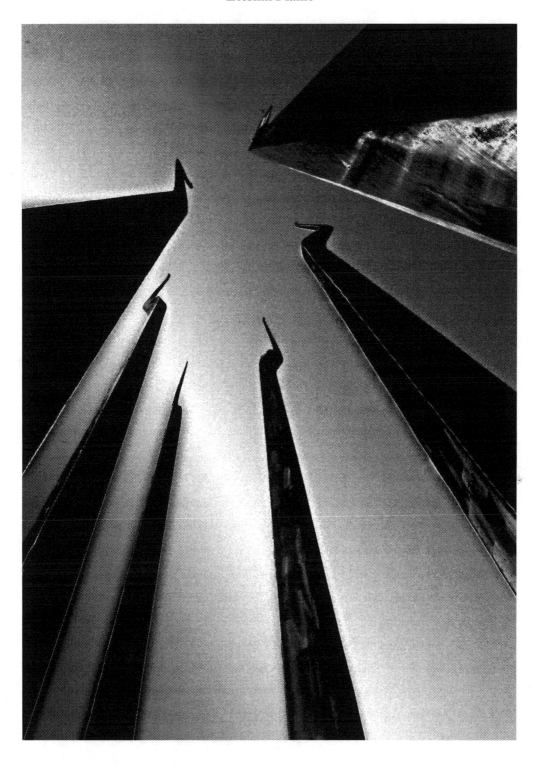

This majestic sculpture that rises approximately 50 feet from the ground sits close to the main entrance of Tampa University. This is a beacon that represents wisdom and knowledge and is ever present for the students of Tampa University. Notice the slight ghostlike effect adjoining some of he spires of this all metal structure.

Building through Window

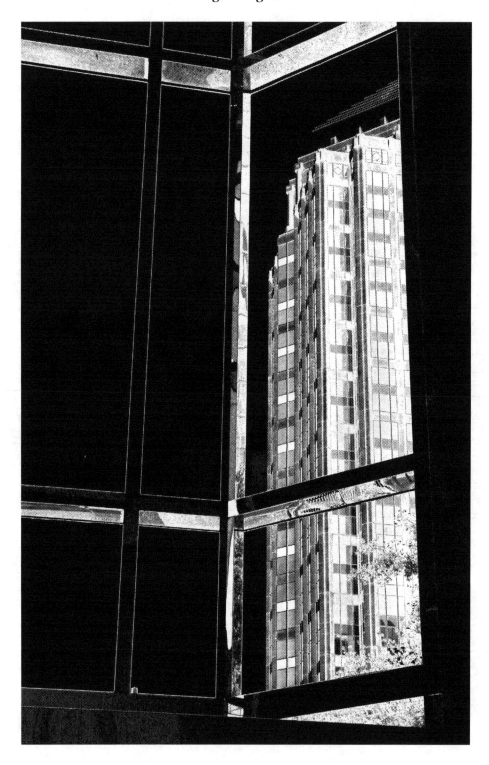

The tall residential building dominates the right side of this image seen through the window of a nearby building. The slight diagonal lines offset by the middle vertical line suggest a slight moment of instability as does the intermittent white lines which are an idiosyncrasy of the solarization process. The break in the two diagonal white lines on the left also suggests a feeling of instability.

Staircase

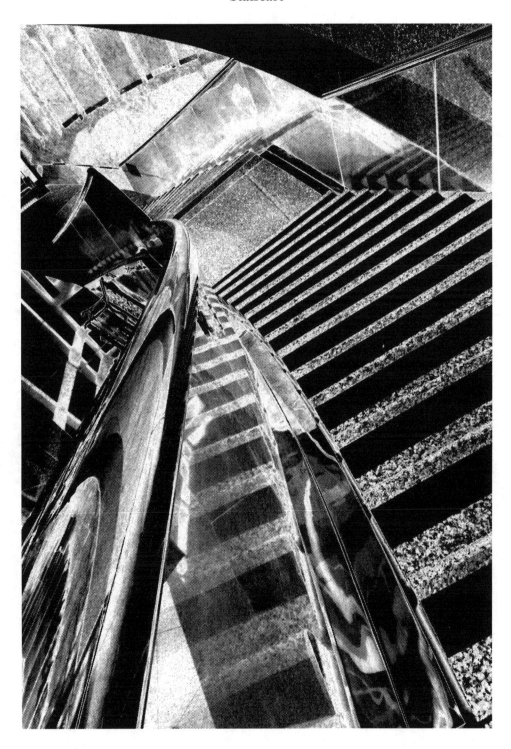

The handrail and wall reflecting the staircase that dominates the foreground of this image are leading from the second floor to the ground level of this office building. The panels in the upper left hand corner are the main doors to the building entrance. There are glass panels on the right side of the staircase and a platform before continuing to the main level.

Entrance

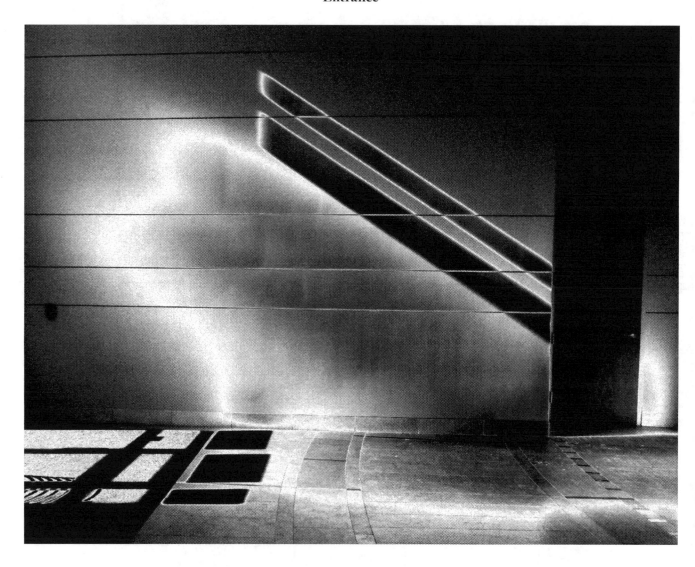

The shadows of the door are seen in the lower left hand portion of this image and the three black graphics are light colored rugs. The two black diagonal lines are light streaming in from the top of the door. The black rectangle on the right side is a door. Notice the doorknob.

Chapel Window

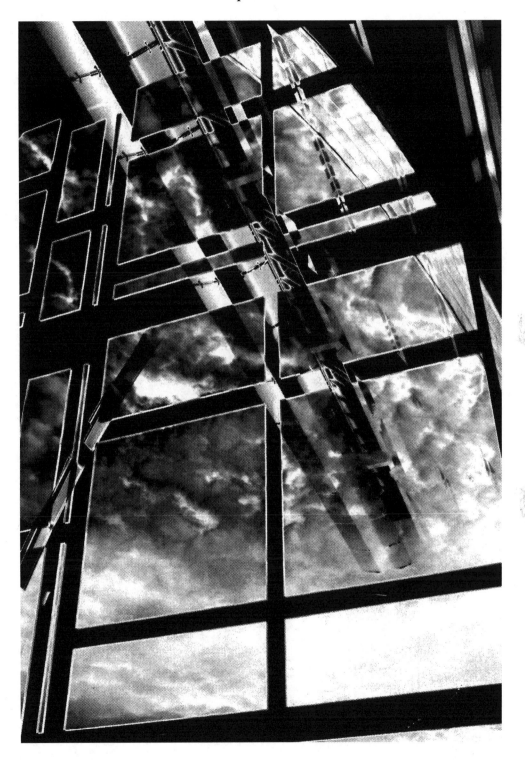

The diagonal lines seen here dominate this image that was captured from inside the Sykes Chapel at Tampa University. Notice the sections of white in some of the intersecting diagonal lines. The curved white line is the outer perimeter of the chapel. The mystic quality of the puffy clouds also adds interest to this image.

Beams

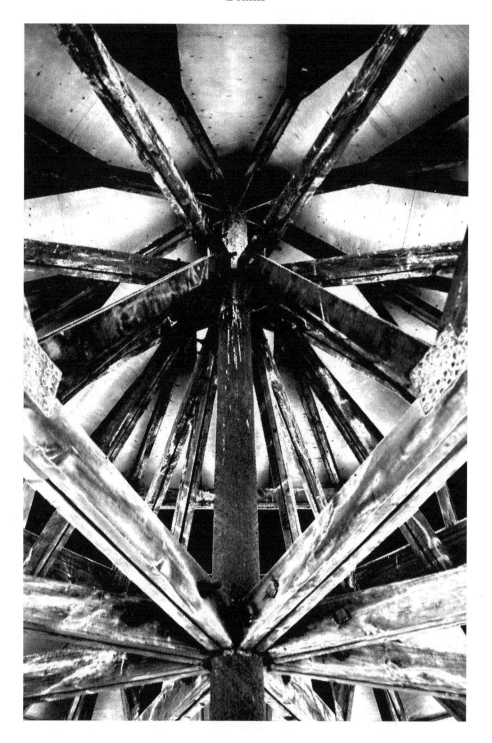

The center pole is the foundation for all the connecting beams. Diagonal lines can be seen moving in all directions from the pole. The bottom lines appear as an optical illusion due to the angle at which the picture was taken. These columns are actually horizontal and extend to the outer part of the gazebo. Light patterns are reflected in the ceiling.

Tracks

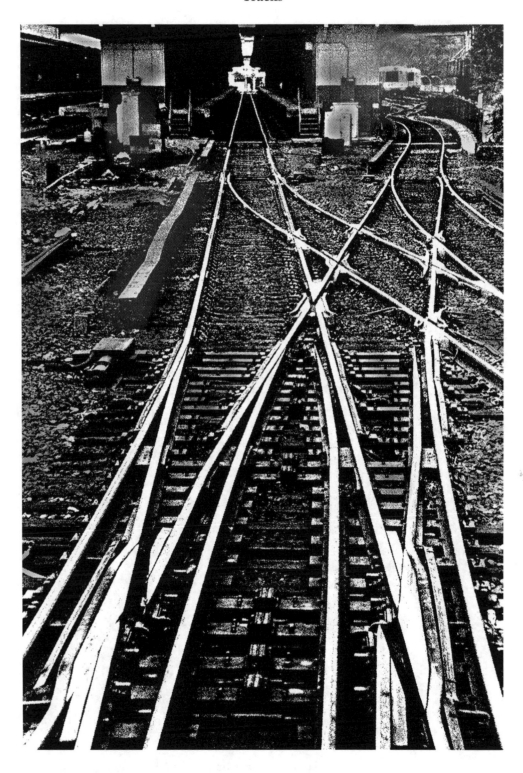

In this grouping of tracks the main track is joined by a subdivision entering the Jamaica Train Station of the Long Island Railroad. Two more sub divisions are added on the right side of the picture. The complex computerized rail system needs to be handled perfectly for efficient and safe operation.

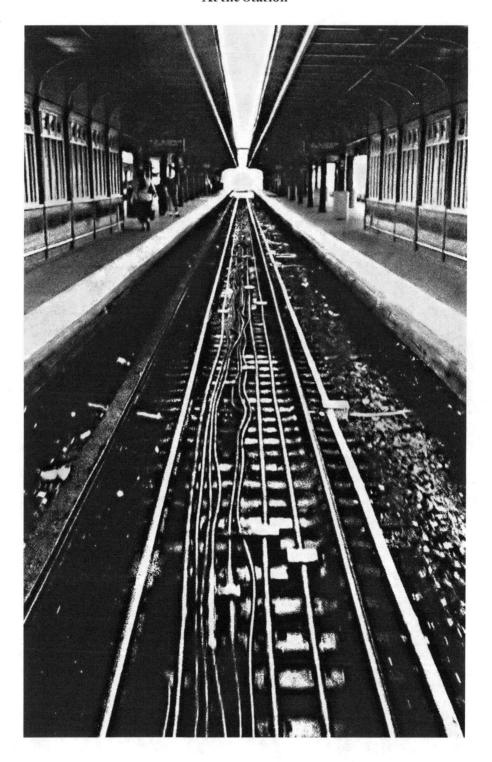

All the directional lines from the tracks, platofrm, and ceiling lead to the outgoing destination. Notice the cables between the tracks. Under the dark diagonal on the side between the track and platform is the electric connection for the smooth operation of the trains. The site is the Hicksville Railroad Station on the Long Island Railroad.

Staircase and Ceiling

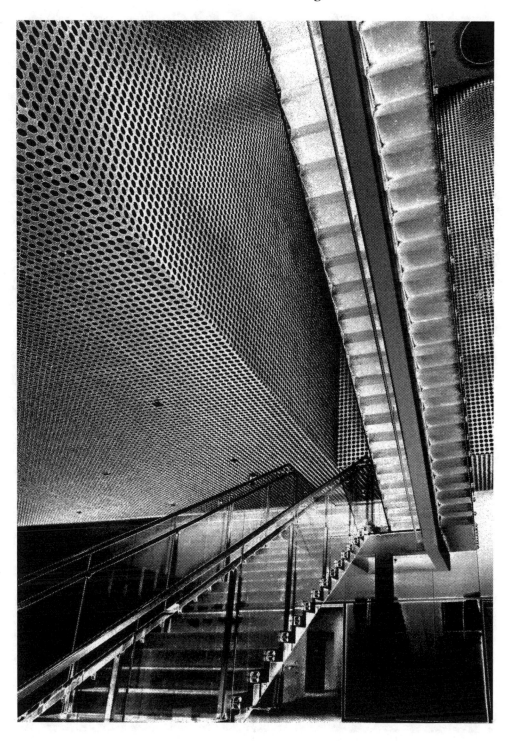

The perforated metal wall and ceiling are the main design ingredients of the Tampa Museum of Art. The main staircase with its glass panels extend from the ground level to the first platform and then continues in the opposite direction. Notice the underside of the staircase to the second level of the museum. The staircase is situated in the center of the lobby.

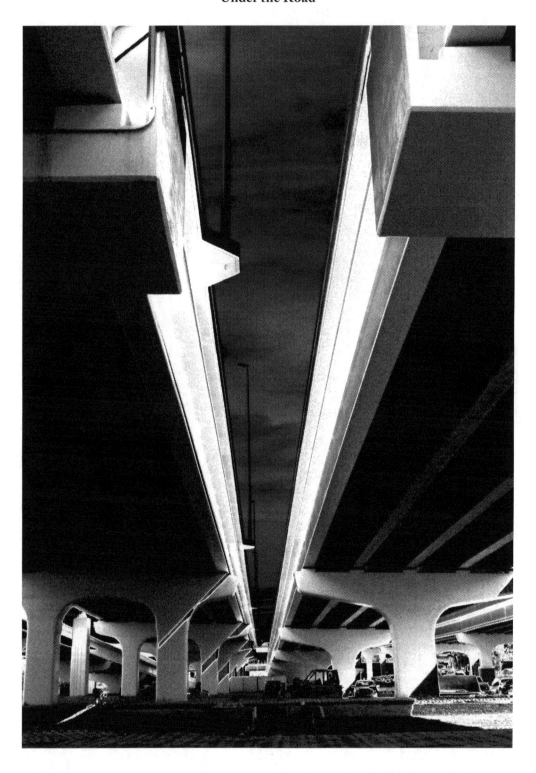

This is one of the many highways that transverse the Tampa Bay Area. The superstructure is stabilized by the T shaped concrete pilings on the right and the N shaped concrete pilings on the left. At the extreme right one can see portions of another road as well as the extreme left. This is a very large thoroughfare.

Wall and Shadow

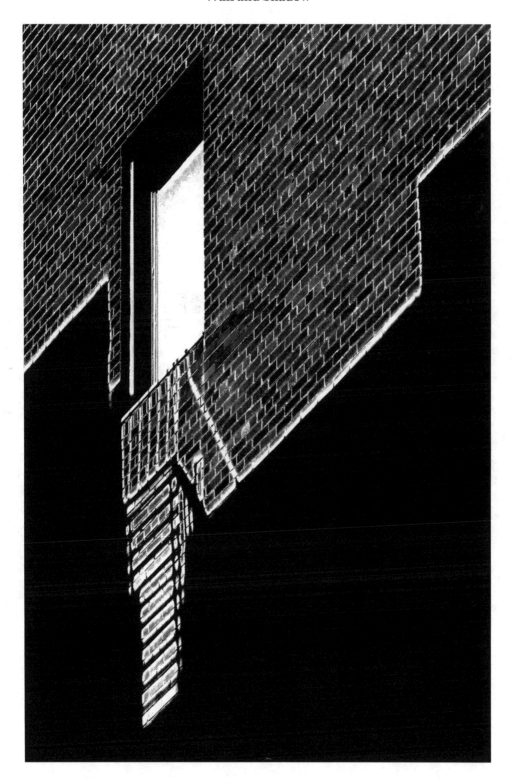

Diagonal lines dominate this image. These lines are partially interrupted with shorter vertical lines which tend to break the pattern. The white window is also a welcome relief in offsetting the brick pattern. The black portion is divided with the textured bricks consisting of a white line of distinction.

Theater Skylight

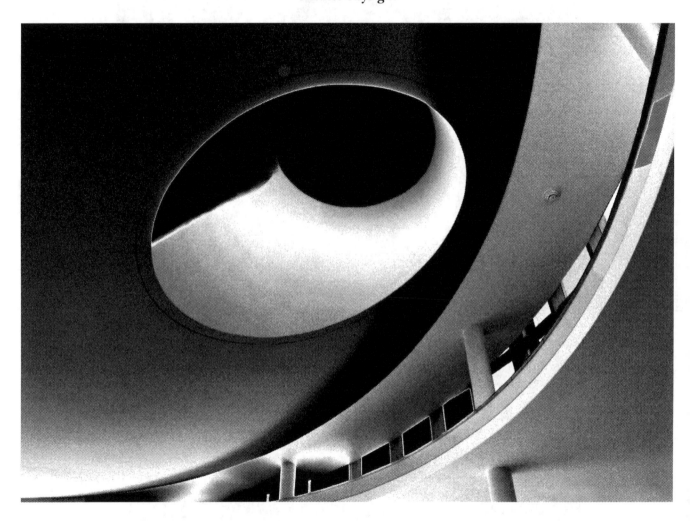

The skylight and second floor view are part of Queens Theater. Queens Theater was part of the New York State Entry in the 1964 World's Fair at Flushing Meadow Park in Queens. The theater survived demolition and is now presenting plays and operettas in its more than 400 seat auditorium. It also houses a cabaret and cocktail bar. The theater is diverse in its presentations and features local, national and international artists.

Center Hall at the Wang Center

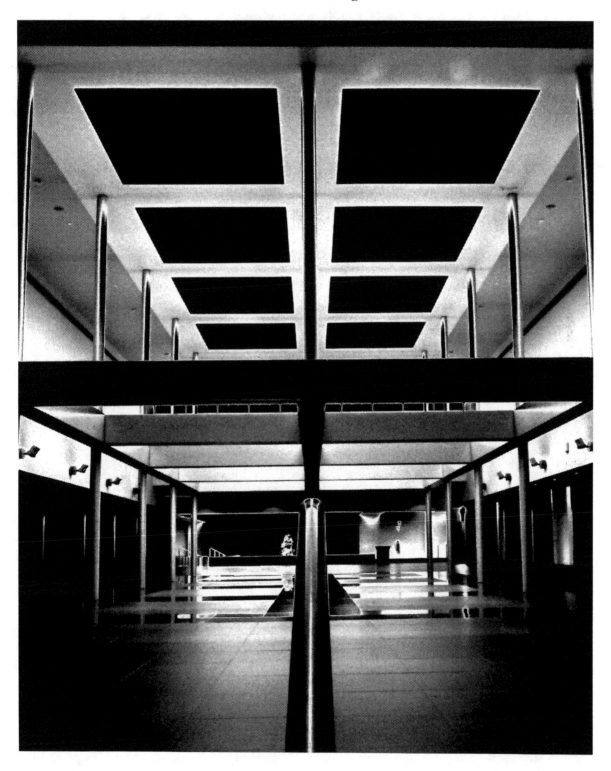

The vertical handrail coming from the bottom center of the picture leads directly to the first level of horizontal lines. The interconnecting vertical and horizontal lines with the ceiling squares make for interesting graphic designs.

Wang Center - Columns and Squares

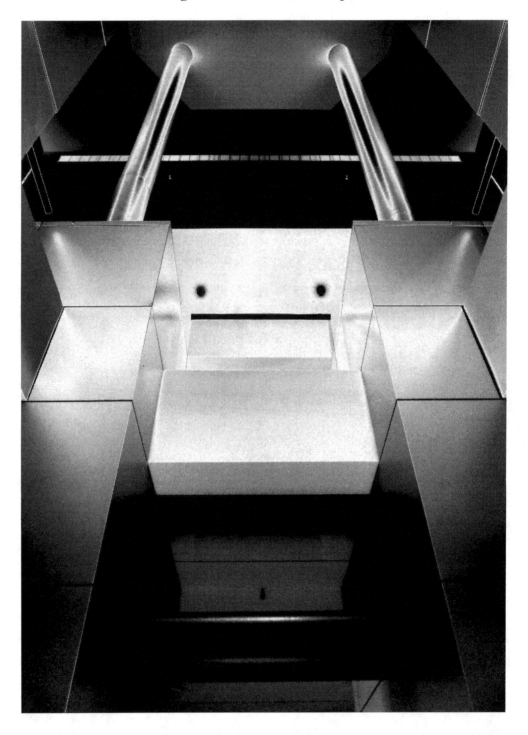

This image could have been placed in the section on Interesting and historical sites. However, the graphics are so interesting and eye catching that it is better placed in the section on Graphics and Designs. The Charles B. Wang Center was a gift by Mr. Wang of $40 million dollars to Stony Brook University and dedicated in 2002. The architect of this unique structure was P. H. Tuan. Please stare at this image for a while and then let your imagination take over. You are sure to come up with some interesting concepts regarding this picture.

PART 4

STREET PHOTOGRAPHY

Since the publication of John Thomsons book, "Street Life in London" in 1877 street photography has been a constant source of activity for the dedicated photographer. The various types of photography such as nature, portraiture, fashion, advertising, etc., all have their challenges which must be met but street photography goes beyond the ordinary in trying to capture as Cartier-Bresson phrased, "the decisive moment". Most street photography deals with people who may or may not be aware of the presence of the photographer and attempting to capture people in their everyday activities and evolve a story from these activities is the basis of the street photographer's challenge. The success of this venture is determined by the final outcome of the image. Is the story of the image complete and can the viewer easily determine whether the photographer was successful or not?

The inclusion of solarization with the street photography image adds another dimension to the viewing process. There is no standard as to the quality of the image and it is entirely up to the viewer to determine their preference as to their opinion and judgment of what they are viewing. The opinions will vary greatly and are often determined by the viewers photography background, life experience and personal preference. Prejudice of any subject should not enter into the evaluation process.

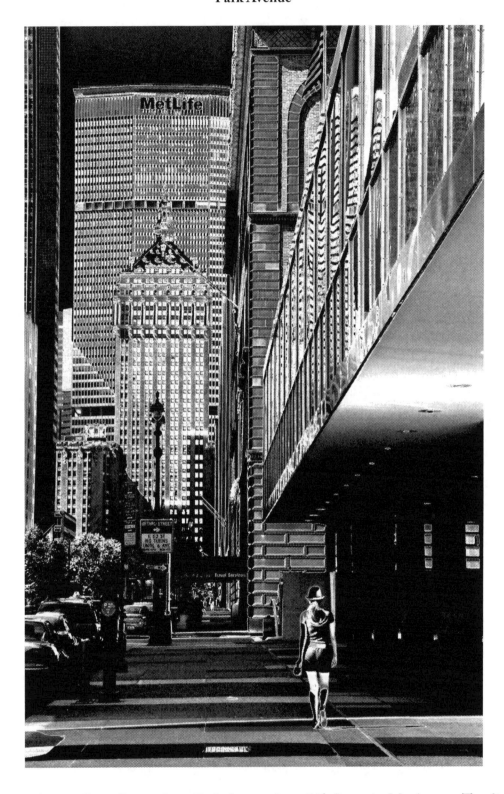

A young lady proudly walks south on Park Avenue from 54th Street in Manhattan. The diagonal vertical lines and graphics in this image tend to dominate throughout. The "Met Life" letters on the top of the building on the top left were formerly "Pan Am" before its demise.

Cold Winter Night

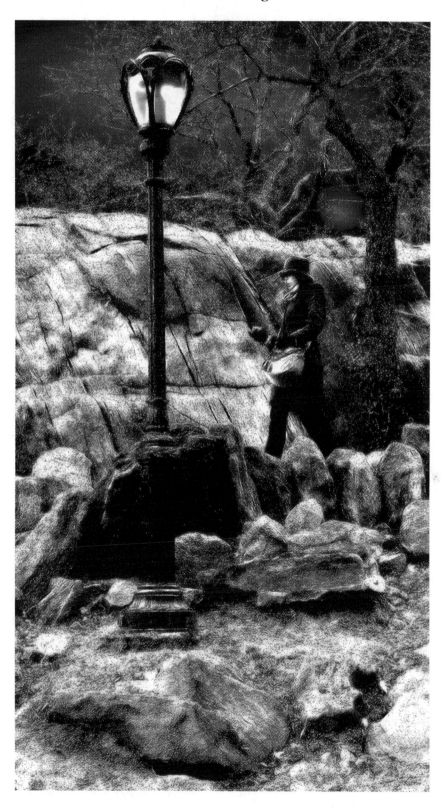

A woman, all bundled up with winter coat and hat, scurries down a hill in Central Park. There are many rocks and boulders in this area as the light stanchion stands as a guiding beacon.

Looking at Ground Zero

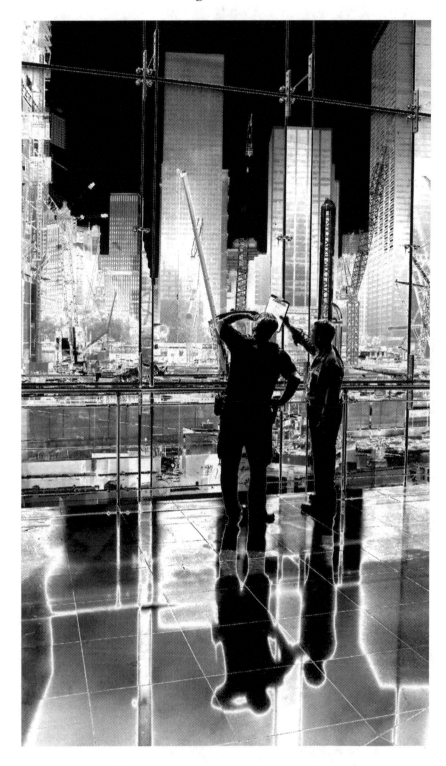

This photo illustrates one man pointing, the other viewing the construction site at the World Trade Center. The viewing point is from a vantage point inside the World Fianncial Center. Notice the cranes and skyscrapers in the background.

Inside Moma

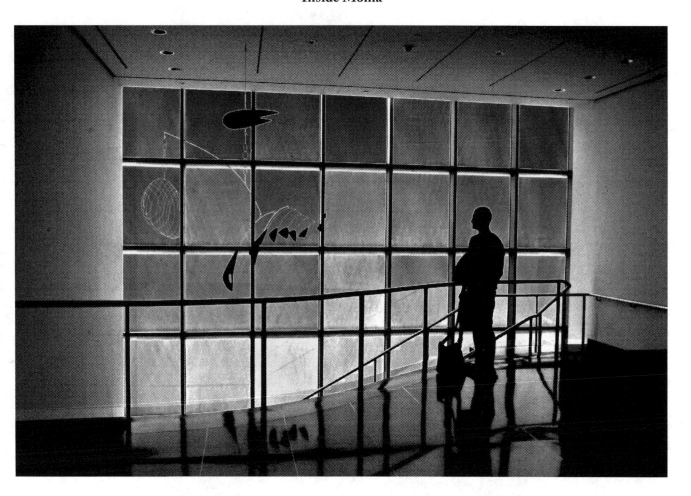

Notice the silhouette of a man with his backpack on the floor. The lobby is next to the Photography Exhibition Hall at the Museum of Modern Art. Notice the Calder sculpture suspended from the ceiling. The square windows and handrail make for an interesting background.

Moma Stairs

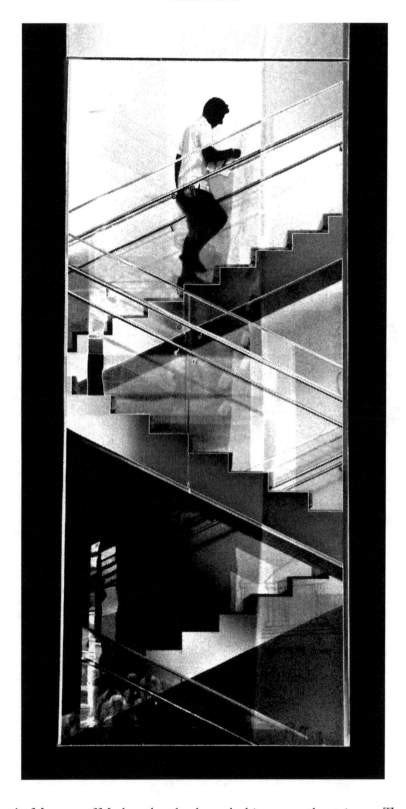

A sole visitor to the Museum of Modern Art slowly works his way up the staircase. The diagonal lines of the stairs and handrails intersecting create interesting graphic patterns.

On the Steps

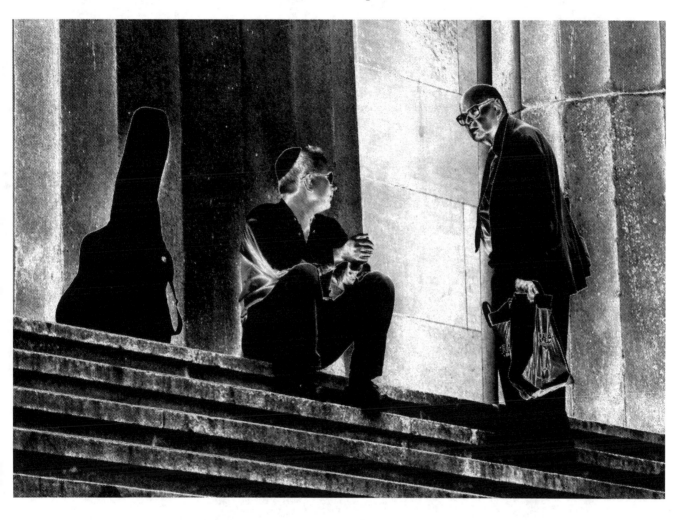

Two gentlemen engage in a change of words on the top steps of the Federal Building in New York City. The seated gentleman has his guitar case close by and has just completed his short concert for the general public. Notice the large column on the right, the concrete squares and the columns on the left. The man on the right carrying his package has just a few more words to say.

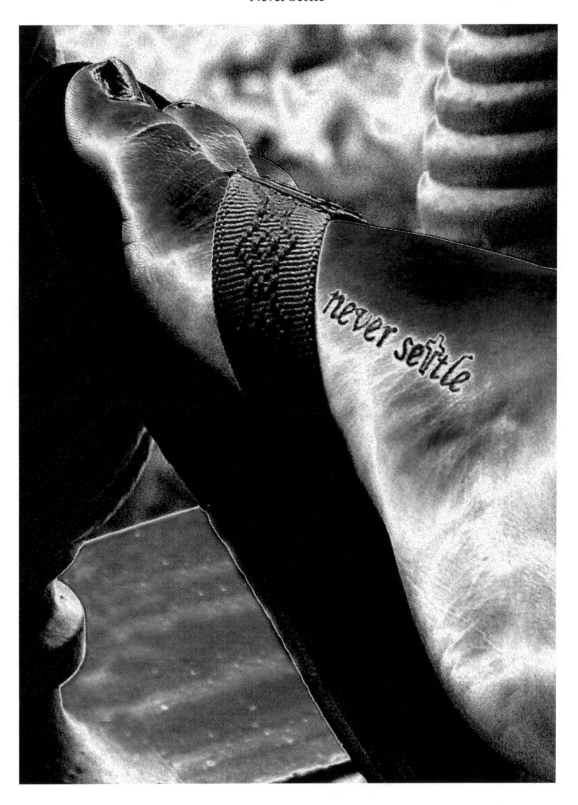

A young lady seated, wearing sandals, carries her philosophy with her at all times. She has a tattoo on her right foot that reads "Never Settle". Notice the cross that replaces one of the t's in the tattoo.

Boy and Girl

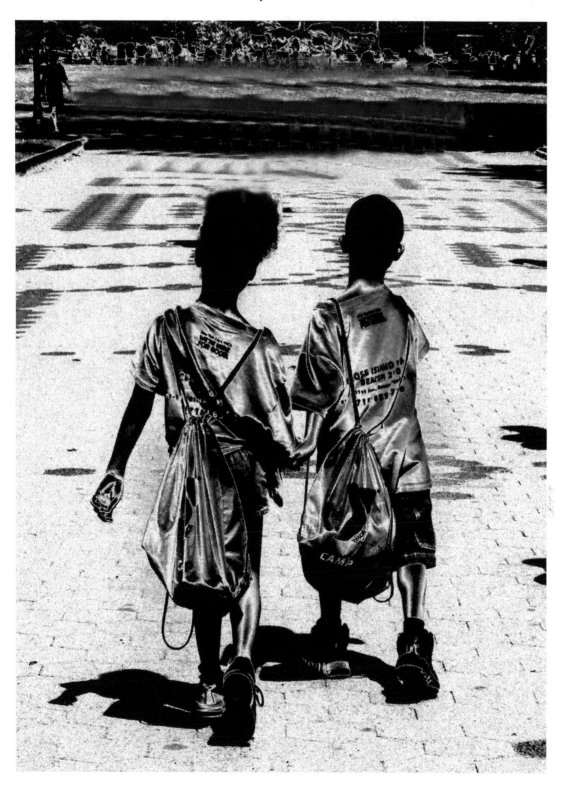

Hand in hand a young boy and girl walk down a path at the Bronx Zoo in New York City. Notice the heavy bags they are carrying. It appears they plan to stay for a while.

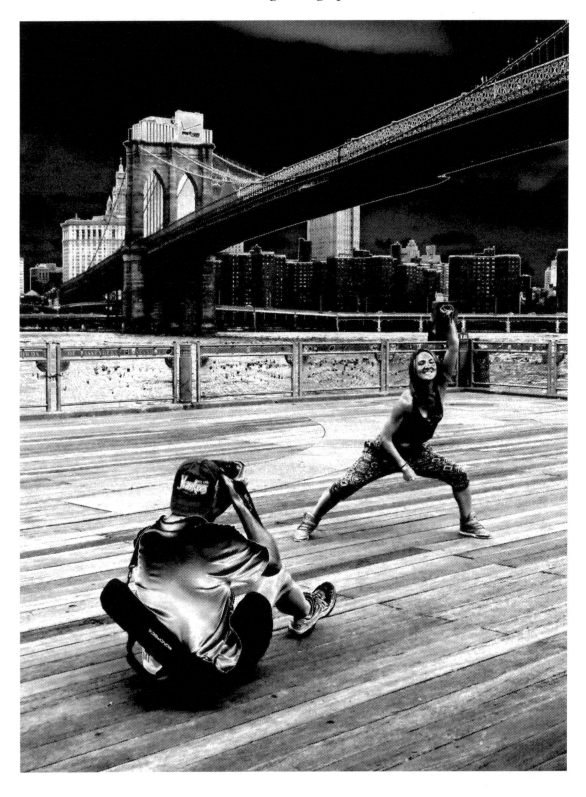

A photographer in a sitting position carefully takes aim at a gymnast going through her daily routines. Notice the Brooklyn Bridge in the background

Waiting

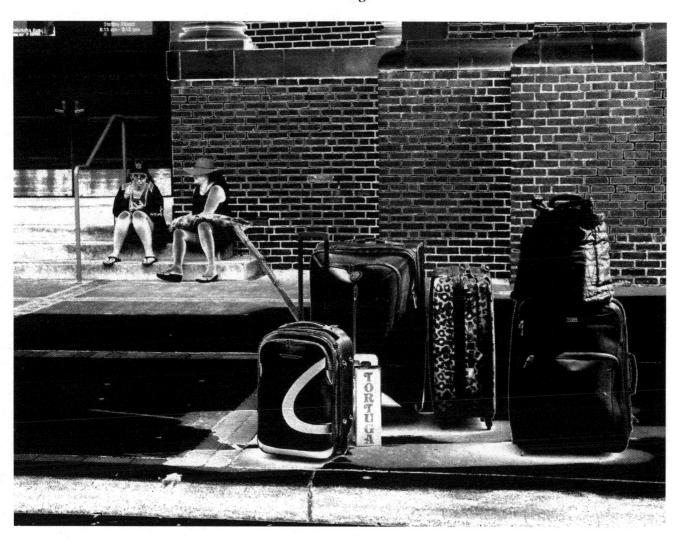

After enjoying their vacation in the Caribean two women are patiently waiting for their transportation home. The site is the railroad station in Tampa, Florida.

To Each His Own

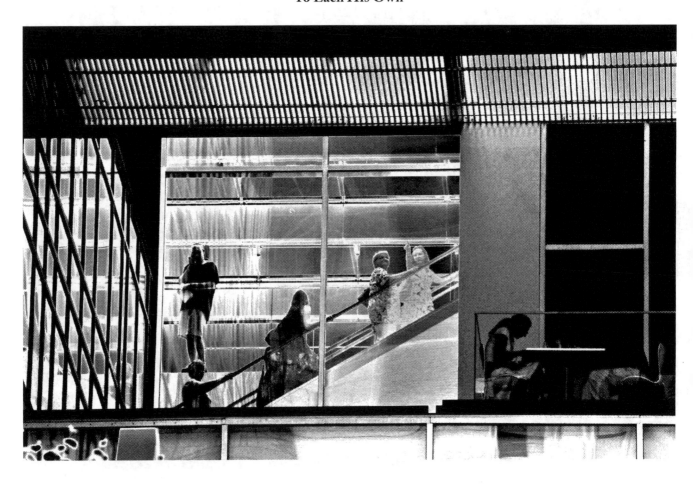

There appears to be very little or no interaction with the people in this image. The man on the left is on the phone, a woman is pointing to her found objective, and the woman on the right is sitting at a table reading her book. All this is happening amidst a plethora of lines and graphics of every description.

Engineer in Locomotive

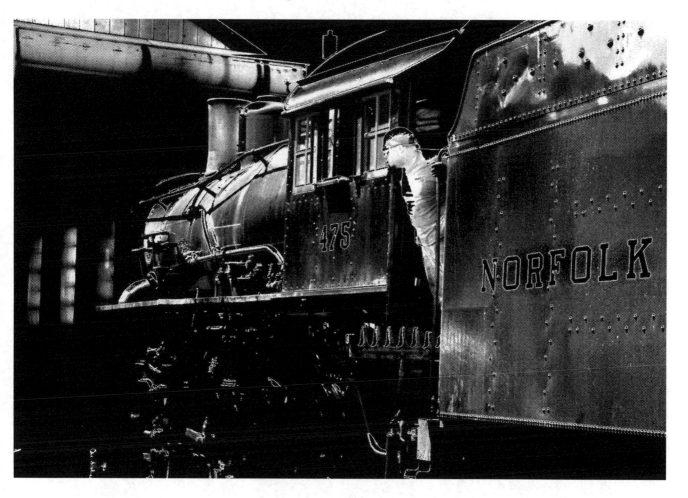

An engineer carefully observes any objects that may be in his way as he slowly moves his steam engine into the repair shop at the Railroad Museum outside Lancaster, Pa.

Silhouette Portrait

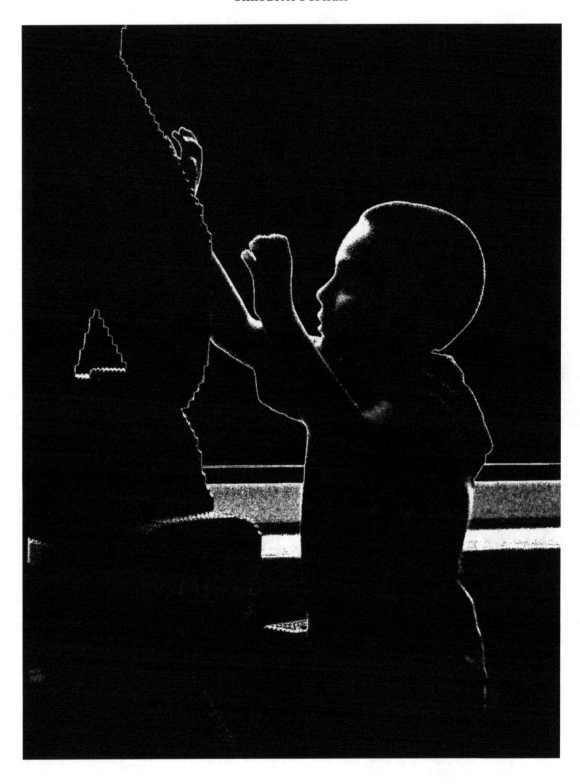

The silhouette profile of this young boy is clearly visible as he attempts his luck at a game machine. The site is the Museum of Science and Industry in Tampa, Florida. Notice the delineated outline that is formed with the solarization process.

Things Dogs Do

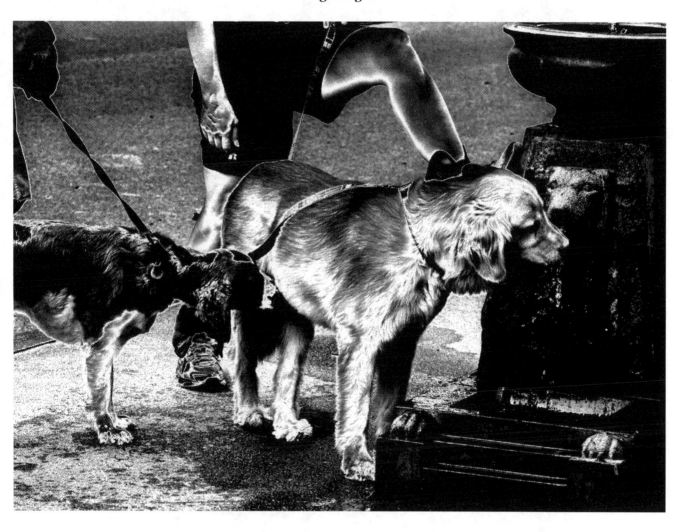

As one dog refreshes himself with a drink of water the other dog takes advantage of the situation. The site is the 92nd Street entrance to Central Park. This is a well known rest stop for dogs and pedestrians.

Metal Man Profile

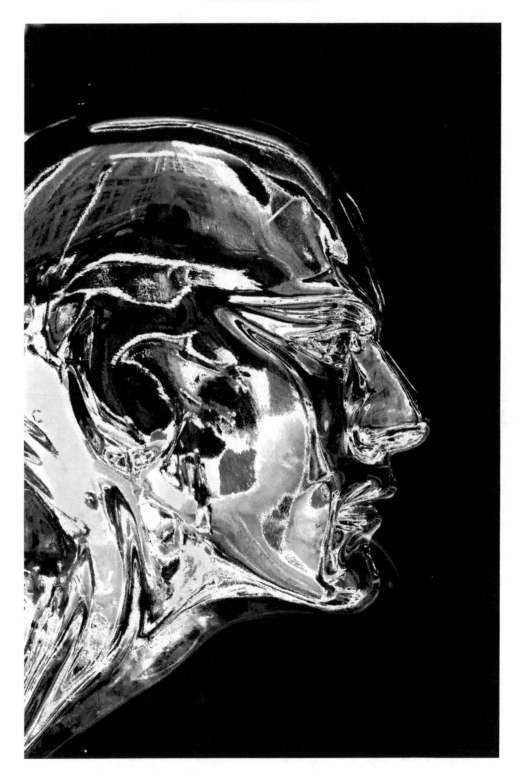

The many tones and lines in this portrait make an interesting topic for discussion. Are there psychological implications? Do the lighter areas from the neck to the dark area suggest something ethereal? The black background suggests a dramatic scenario.

Metal Man Moving

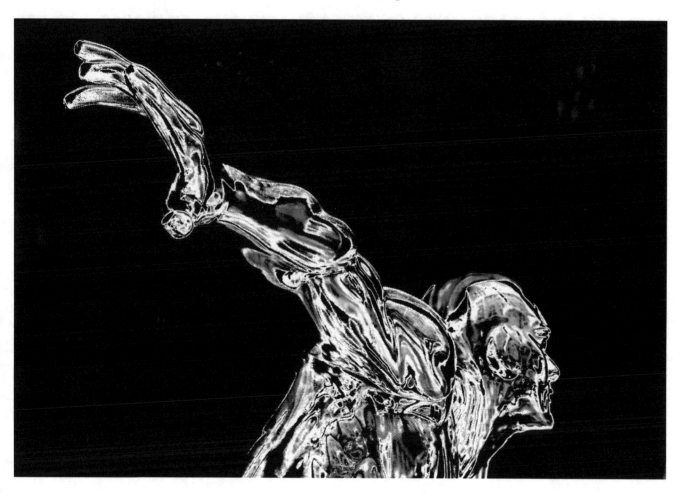

Illustrated here is another view of the metal man. This time some form of action is suggested. Notice the leading line from the hand, arm, to the body and ultimately to his head. All the tones from black to white offer interesting and complex designs within this figure.

The Beatles

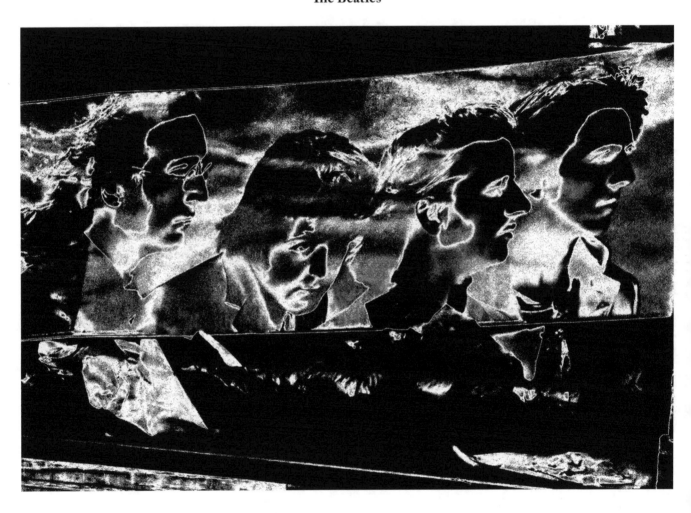

This poster was discovered in a junk yard and was about to be discarded. The two surviving members of the Beatles, Paul McCartney and Ringo Starr, are still active as performers. In all probability the Beatles were the most popular performing group in music history.

Reflection

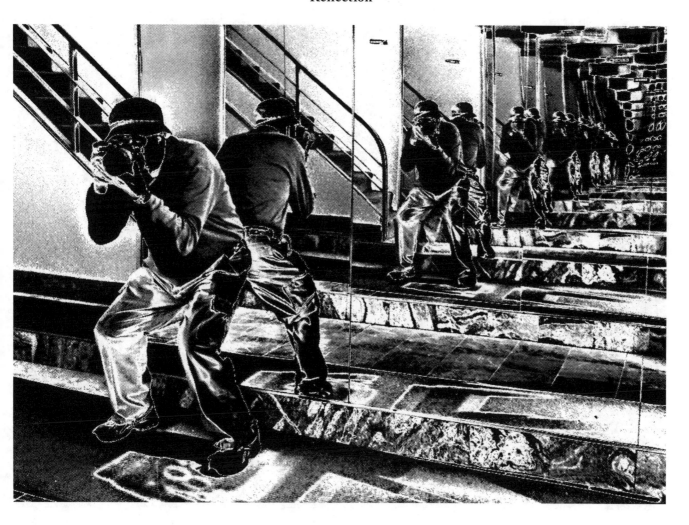

A photographer gracefully sets himself to take a picture inside a building hallway. The double mirrored entrance to the building shows his reflection ad infinitum, first back to back and then the repetitions of the original reflection.

Working the Wheel

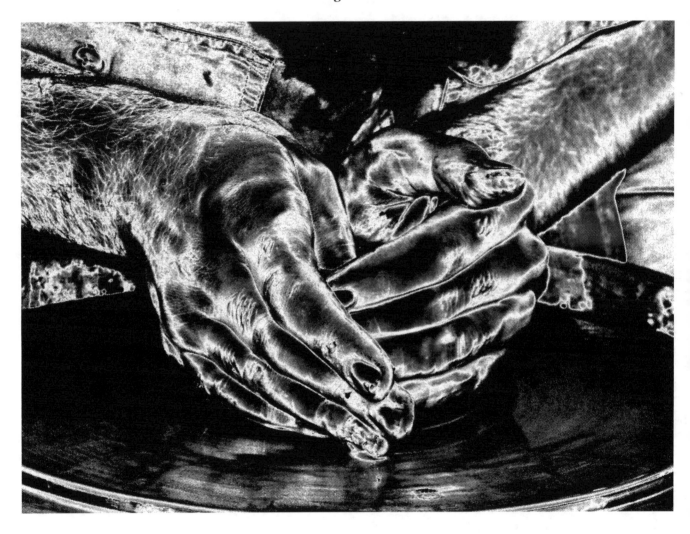

The cupped hands are on the piece of clay that is being formed into a new piece of pottery. The wheel is spinning and the hands are just above the wheel. The diagonal lines of the arms lead directly to the subject of the image.

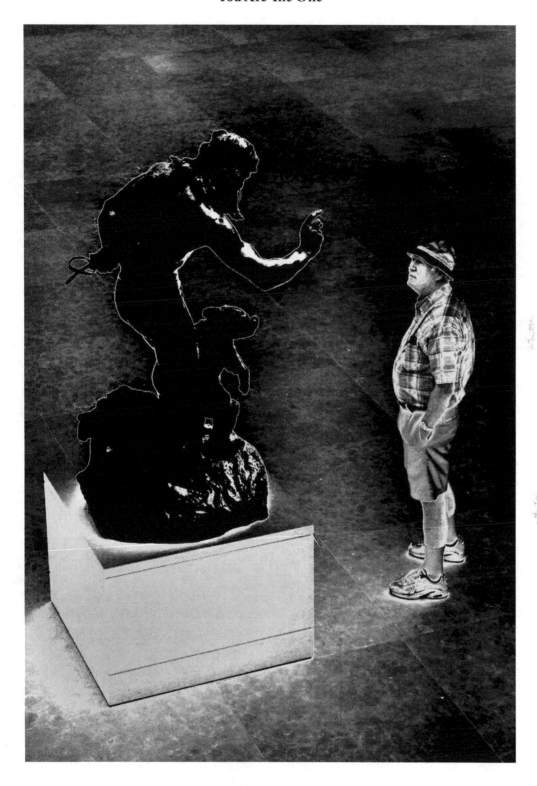

This statue in the Metrop0olitan Museum of Art with its arm extended is pointing directly at the man below. The defiant look of this individual with his hands in his pockets is obvious. He is probably thinking "You are not judging me".

Under he El-Woodside

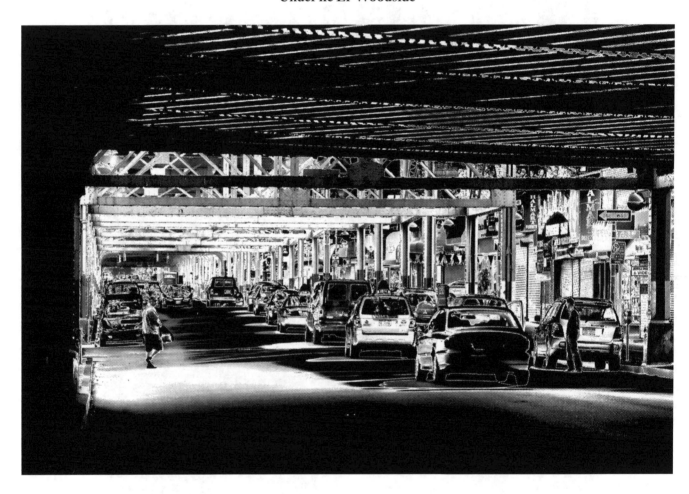

A man bravely crosses Roosevelt Avenue in Woodside, Queens. The image is dominated by the superstructure of the el which neatly frames the traffic below. An intersecting pattern is formed by the horizontal and vertical steel beams.

Watching the Rain

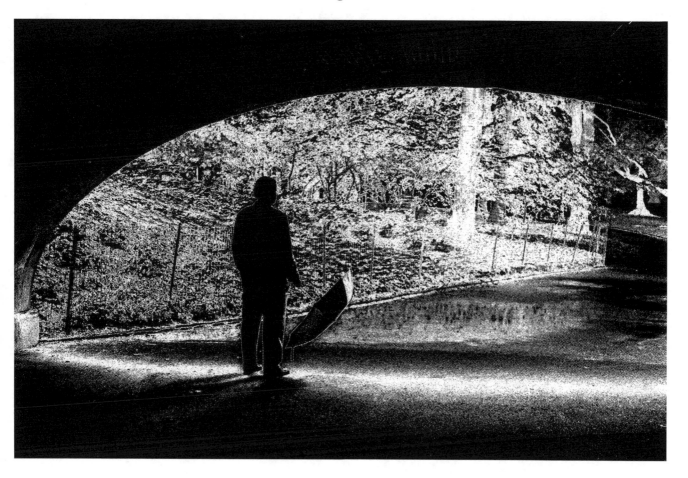

A man patiently waits under a bridge in Central Park for the rain to subside. With the opened umbrella in hand he is observing the end of the apparent thunder storm. He is framed by the arch of the accompanying bridge and the accompanying shadow.

ABOUT THE AUTHOR

Being raised in Manhattan presented many cultural opportunities that were just a walk, subway ride, or bus ride away. Full advantage was taken of these cultural activities, and a deep appreciation of music and art was developed. After three years in the Marine Corps, Joe received his bachelor of music and master of music degrees from Manhattan School of Music. This was followed by a teaching career, a period of musical composition, many of which were published, and postgraduate education at New York University, which resulted in a PD (professional diploma).

Joe then became a director of music in a school district on Long Island. He was also on the adjunct faculties of Dowling College and Five Towns College. It was traveling that first got Joe interested in photography. After doing extensive shooting in Europe and presenting slide shows of his travels, he became interested in sports photography. His professional sports photos have appeared in national magazines. This interest further developed to include nature and fine art photography. Joe has been dedicated to black-and-white photography since the early '70s, when he built a darkroom in his home.

Infrared street and nature photography are his main areas of interest, and Joe takes advantage of the opportunities as they are presented. It has been an enjoyable, challenging learning experience developing different areas of photography. The objective is to achieve quality results that can be enjoyed and appreciated.